IMAGES
of America

NEW YORK CITY'S
HARBOR DEFENSES

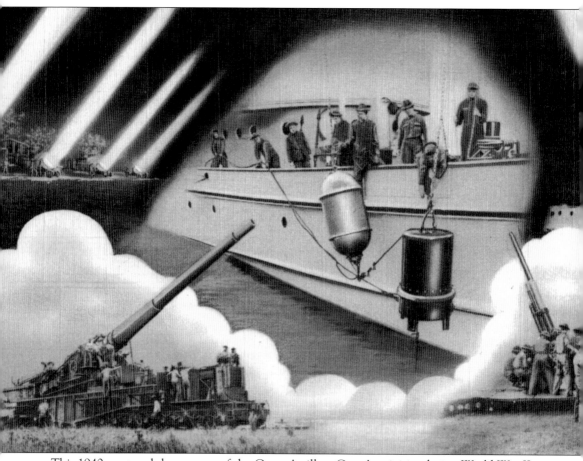

This 1940s postcard shows some of the Coast Artillery Corps' activities during World War II as it defended New York's harbor, although the montage was created years earlier. Railway artillery, shown in the lower left, was used effectively against land targets in Europe during World War I, but no batteries were emplaced in New York's seacoast fortifications. Searchlights, antiaircraft guns, and mines were, however, important in the harbor's 1940s defense. (NA.)

IMAGES
of America

NEW YORK CITY'S HARBOR DEFENSES

Leo Polaski and Glen Williford

ARCADIA
PUBLISHING

Published by Arcadia Publishing
Charleston SC, Chicago IL, Portsmouth NH, San Francisco CA

Printed in the United States of America

Library of Congress Catalog Card Number: 2003106283

For all general information contact Arcadia Publishing at:
Telephone 843-853-2070
Fax 843-853-0044
E-mail sales@arcadiapublishing.com
For customer service and orders:
Toll-Free 1-888-313-2665

Visit us on the Internet at www.arcadiapublishing.com

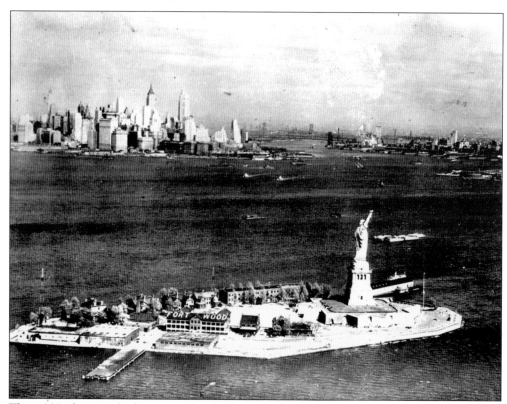

This 1939 photograph shows two familiar harbor sights: the Statue of Liberty and New York City's skyline. The soldiers at Fort Wood are not attempting to advertise their post by painting its name on the roof of their barracks. In the 1920s and 1930s, army camps were identified in this way to help airplane pilots navigate during long-distance flights. (EI.)

CONTENTS

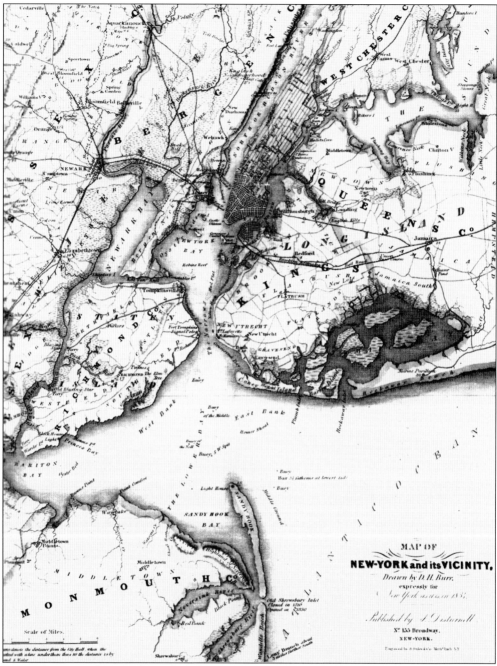

Parts of New York Bay, also called the upper bay, have been filled in since this 1834 map was drawn. No bridges spanned the rivers, and most of Brooklyn, Queens, Richmond, and Westchester was farmland and small villages. Harbor forts were placed at the tip of Manhattan, on three islands in the upper bay, at either side of the southern entrance into the harbor at the Narrows, and at the eastern entrance at Throgs Neck. Sandy Hook, New Jersey, points toward the Narrows channel, and it was also fortified to protect the lower bay. (NA.)

INTRODUCTION

New York City's large and sheltered natural harbor, a great gift of the Ice Age, had to be well and continuously defended. The harbor, which glacial melting and runoff formed into the present bays, rivers, islands, and estuaries comprising the port of New York and New Jersey, was an ideal location for a Colonial settlement. Over the following 400 years, the harbor fostered thriving commercial and residential cities. However, the growing value of the harbor to America also made it a tempting location for seaborne attack by enemies. This port city and its trade were periodically threatened from the 17th through the 20th centuries, and an increasingly complex series of coastal fortifications was constructed to protect it. These forts did prove an effective deterrent, as only the English, twice in Colonial times, successfully invaded.

The first of these more than 60 harbor fortifications was begun at the tip of Manhattan by the Dutch in 1624. It was meant to protect the colony they started there against both waterborne and land attack. The English captured their fledgling settlement 40 years later and rebuilt their wooden fort, strengthening it and adding a wall across the island to enclose the town, which was surrounded by water on the other sides. After the American Revolution established a new country on these shores, European wars seemed likely to involve the new United States, and its response was to construct a group of masonry harborside and island forts to dissuade possible enemies from capturing and burning the city and the ships harbored there. Most of these forts were located around the lower part of Manhattan, and of these, Castle Clinton alone survives. Two others—Fort Jay and Castle Williams—were placed on Governors Island, and both of these can be visited now. One more, on Ellis Island, was torn down for the immigration station, but sections of its foundation have been uncovered and may still be seen. The Statue of Liberty was placed atop Fort Wood (another of these forts) on Liberty Island, and a museum fills its old stone walls.

The nearly mile-wide, well-named Narrows passage (between Staten Island and Brooklyn, separating the upper bay from the lower bay and the Atlantic Ocean beyond) was an ideal fortified location for keeping enemy ships out of the upper bay entirely. Fortifications were built on both shores beginning in the 1700s. None remain. The outermost of the 1800s harbor forts, Fort Lafayette, sat on a reef in the Narrows near the Brooklyn shore, but it was demolished for one of the towers of the Verrazano-Narrows Bridge. A large granite fort was also begun on the Sandy Hook peninsula in New Jersey, where its many guns would be able to fire on enemy ships attempting to sail into the lower bay. Only small sections of its walls can now be seen.

Through the 19th century, as the range of naval guns and their counterparts ashore was increased, first because of stronger construction and then by the rifling of their barrels, forts had to be located farther from the city to keep it out of the range of these newer weapons. Forts also had to mount many more guns to enable effective hits by at least some of them and to prevent a run by, a tactic in which a number of enemy ships attempts to sail quickly past a fort before most of them can be damaged by its guns. More guns meant higher fortifications, and enclosed granite citadels with several tiers of gun casemates were the result. All of these survive at the Narrows and near Throgs Neck and are open for visiting.

Steam-powered warships also caused rethinking of the location and types of forts that would be effective against these faster targets, not dependent on changing winds for motive power anymore. Further, thick granite walls protecting massed guns were proven vulnerable to rifled artillery in the Civil War, and all stone forts were suddenly obsolete. Ironically, the best protection against modern pointed shells was yards of earth, the same protection once used in the first types of harbor forts, and thus batteries of Civil War–era guns were placed behind

embankments of earth at several of the harbor forts in the 1870s, their shells and gunpowder safe under earth-covered magazines.

Several engineers at home and abroad designed disappearing carriages for long-range rifled guns, the idea being that such a gun could fire at an enemy ship and then mechanically disappear down behind a concrete wall, further protected by an earth embankment. Its men and ammunition safe, this gun could be reloaded and aimed while hidden from the ship's return fire. It could then be raised quickly to fire once again. Two such guns were emplaced together and aimed accurately by means of a fire control system using widely spaced observing stations and a plotting board that replicated in miniature the harbor and the defending guns. Enemy ships were located on the board by geometric triangulation. The United States selected the reliable Buffington-Crozier design in the 1890s and constructed 25 concrete emplacements for guns of 6- to 12-inch diameter barrels at six harbor forts, including three to guard the eastern approach to the harbor from Long Island Sound.

The Sound opens into the harbor's East River at a channel between Queens and the Bronx, and two points of land there are only 4,000 feet apart. Granite forts, both still standing, were begun at Throgs Neck and near Whitestone in the 19th century, and concrete emplacements for disappearing guns were also later placed at these locations. Except for new sites in the Rockaways and at Navesink Highlands near Sandy Hook, no new locations were required for New York's harbor forts after the second decade of the 19th century; the well-chosen sites for masonry structures were used for the next three series of more modern weapons over the following 130 years.

The increasing range of guns and, after World War I, the bombing power of airplanes, showed the necessity of having new emplacements and another shoreline location in the 1920s. Batteries for long-range guns, able to deny the entire lower bay to enemy ships, were constructed at Sandy Hook and at the new fort site at Rockaway Beach. During World War II, these guns were covered with earth and thick concrete casemates, and modern 16-inch guns, the same caliber as the largest naval weapons of the time, were emplaced above Sandy Hook at Navesink Highlands. Batteries of casemated 6-inch guns were also built at three of the harbor's forts, and all the 1940s guns were carefully aimed by radar and mechanical or electrical computers.

All coastal fortifications in the harbor were abandoned after the war. Airplanes, missiles, and atomic weapons rendered them ineffective in protecting the bays and the city from such close-in locations. Most of the army bases on which they were built remained in military use for a time, and then all but two—Forts Hamilton and Schuyler—became parks. Their coast defense installations are still visible but now seem of little importance to the life of the harbor—quite the opposite of their historic role.

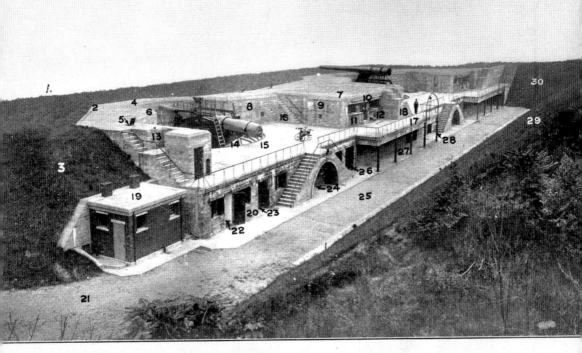

A Seacoast Gun Battery

1. Exterior Slope of Parapet.
2. Superior Slope of Parapet.
3. Interior Slope of Parapet.
4. Blast Slope or Apron.
5. Magazine Ventilator.
6. Interior Crest.
7. Traverse.
8. Interior Wall.
9. Traverse Wall.
10. Canopy.
11. Reserve Table.
12. Delivery Table.
13. Observing Station (Crow's Nest).
14. Gun Platform.
15. Loading Platform.
16. Platform Stairs.
17. Corridor.
18. Corridor Wall.
19. Latrine.
20. Parade Wall.
21. Approach.
22. To Oil and Tool Room.
23. To Shell Room.
24. To Magazine.
25. Battery Parade.
26. Office.
27. Gallery.
28. Crane.
29. Interior Slope of Parados.
30. Traverse Slope of Parados.

This view of Battery Dix at Fort Wadsworth shows the features of an Endicott-era Coast Artillery fortification. Construction started on this concrete emplacement for two 12-inch guns on disappearing carriages in 1902, and it was one of 19 such batteries for the 10- and 12-inch long-range rifled artillery weapons, which were the major defensive guns in New York's harbor for over 40 years. The gun on the right is raised in the firing position, while the other is down behind the protective parapet for loading. Viewed from the water, the landscaped earthen hill completely concealed the battery and absorbed shellfire from enemy ships. (NA.)

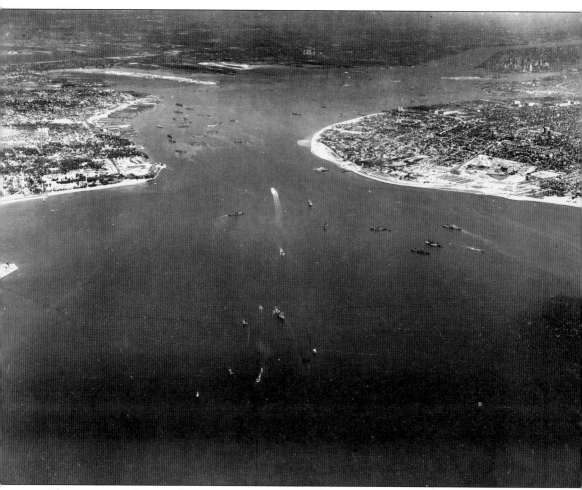

This gateway to America for immigrants, visitors, and commerce might also have been an access for seaborne attack and invasion had the harbor not been defended by a succession of strong and well-sited fortifications. The outer bay is in the foreground of this 1942 aerial view, with the Narrows (now the site of a bridge) sheltering the upper bay and the Manhattan, Brooklyn, and New Jersey shorelines with their piers and the Brooklyn Navy Yard. (GN.)

One

PROTECTING
THEIR COLONIES

The first known European to visit the outer bay was Florence's Giovanni da Verrazano in 1524, exploring for King Francis, who claimed the entire continent as "New France" but began no settlement. The following year, a black Portuguese named Esteban Gomez, exploring under the Spanish flag, became the first to sail past Staten Island to explore the inner bay and venture up what is now the Hudson River, but no settlement followed that voyage either. It was the Dutch—first as mapmakers and traders and then as colonists after Englishman Henry Hudson's 1609 visit while searching for the supposed Northwest Passage—who decided to begin a permanent settlement by the harbor.

In 1624, several families settled on Nut Island, now Governors Island, and were joined the following year by 45 more people and several hundred needed farm animals. The settlement soon became too crowded and was moved to the nearby larger island of Manhattan. New Amsterdam grew, but with English settlements very near it in Connecticut and Long Island. In 1664, James, Duke of York, sent four warships to capture the Dutch colony. A peaceful surrender occurred, and except for a short time when the Dutch returned, New York remained English for the next 119 years.

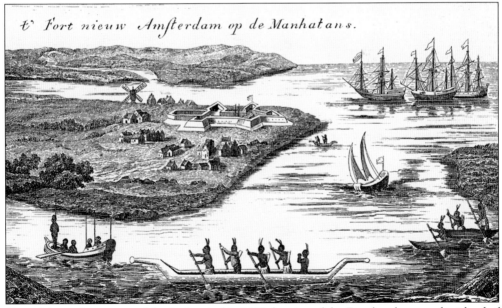

t' Fort nieuw Amsterdam op de Manhatans.

One of the earliest views of the harbor is this 1635 drawing of the Dutch colony on the island of Manhattan. After landing, the Dutch soon needed to erect a fortification, here of wood, to protect themselves from Native American and foreign attacks. The Dutch allowed their once effective fort to fall to ruin, making its capture almost certain when the English arrived. (NA.)

11

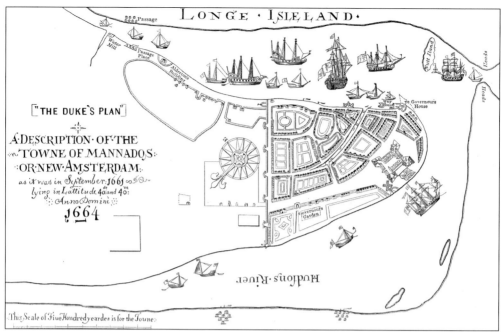

This map shows the four-bastioned Dutch fort, which the English rebuilt. The wall crossing the island protected the town and fort from unexpected attack and gave a future street its name. Leading from the fort is a broad way allowing troops to move quickly in defense. In 1673, Holland recaptured Fort George by landing soldiers nearby during a brief war with England, but newly named Fort Orange changed nationality after a peace treaty. (NA.)

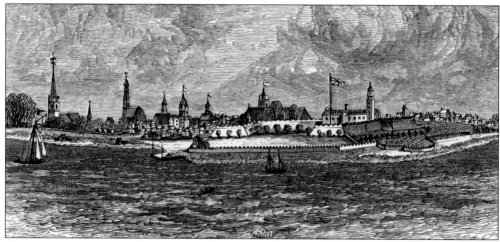

The spires of stone churches and the British flag above the masonry of Fort George dot the skyline of New York in 1704, indicating the security and permanence of this colony. Crenelated walls extend from each side of the fort as outer defenses to prevent an enemy from landing and to protect the nearby dock. So secure do the colonists feel by this time that they have planted trees along the fort's walls, lessening its defensive capability. (NA.)

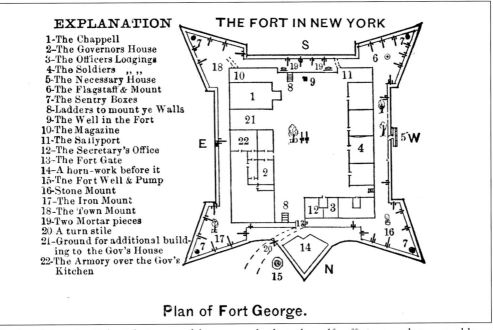

THE FORT IN NEW YORK

Plan of Fort George.

Enclosed forts in Colonial times and later were built to be self-sufficient and strong, able to withstand a long siege until outside help could relieve them. Fort George, which became James, Hendrick, Henry, Anne, and George again, according to the monarch, was defensively strong while it was maintained. The "necessary house" by the west wall was also known as the privy, although it was not too private. (NA.)

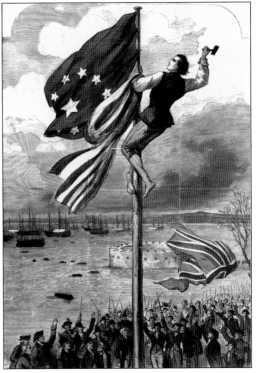

This patriotic drawing symbolizes the 1783 departure of English troops from the harbor after the Revolutionary War. As they row out to their ships to the sound of cheering, a man has climbed Fort George's flagpole to cast down the Colonial flag and replace it with his new country's. Departing troops often greased flagpoles to delay such gestures. Fort George was demolished in 1790. Castle Clinton, wrongly shown here, was not completed until 1811. (NA.)

13

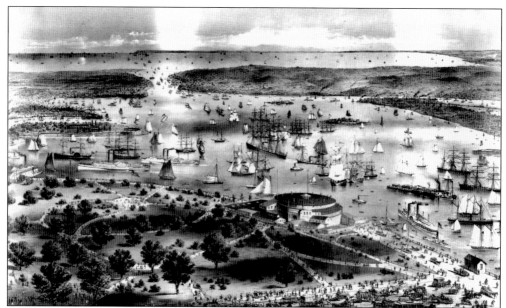

Seen in this print are Manhattan, the upper bay, the Narrows, and the lower bay, with Sandy Hook curving from the New Jersey shoreline in the right background. The bays are as crowded with shipping as they would be in 1872. Castle Clinton is at the water's edge, and Governors Island, with its two forts, is to the left. Ellis and Bedloe's Islands, also the sites of forts, are at the right center. (NA.)

This opposite view of the bay was drawn before steam power prevailed over sail. Fort Wood's walls are on the left, with Fort Gibson on Ellis Island behind. The upper bay was made easier to defend in the 19th century because of the islands. Smoothbore coastal guns of this time had an effective range of less than a mile, but the nearby island forts and the slowness of sailing ships made the harbor's defense possible. (NA.)

Two

DEFENDING THE UPPER BAY

The new United States was unprepared for its declaration of war against England in 1812, but New York's harbor fared better than Washington, which was entered and burned by the British who sailed up Chesapeake Bay. Baltimore's harbor was saved by the defenders at Fort McHenry in the harbor, and the words of America's national anthem resulted. Extensive fortification construction around New York just before the war deterred the British from attacking here.

Of the 22 fortified sites built to protect the city and its inner harbor, Castle Clinton, Fort Jay, Castle Williams, and Fort Wood survive today, although altered. Earthen and wood or stone waterside batteries—such as at Gravesend Bay in Brooklyn, Corlears Hook in Manhattan near the Williamsburg Bridge, at the Narrows, Hallets Point on the Queens side of Hell Gate, and at several places along the west side of Manhattan—were built to deny an enemy a safe location for landing. Blockhouses were erected on the hills of Manhattan, and an 1,800-foot iron chain was placed across the Hudson River. Long Island Sound and the outer bay were blockaded by English warships, but no entry was made into the harbor.

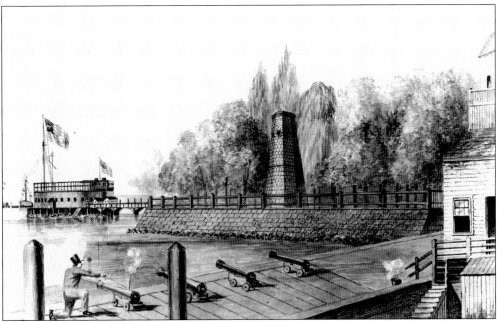

The Southwest Battery, begun in 1808, was renamed Castle Clinton in 1815 to honor New York's mayor, DeWitt Clinton. Built of red sandstone on rocks 200 feet offshore, the fort was reached by a wooden bridge that could be burned if the fort were attacked. Its guns fired through the embrasures seen around the fort's wall. The four cannons are being discharged as part of a celebration. (NA.)

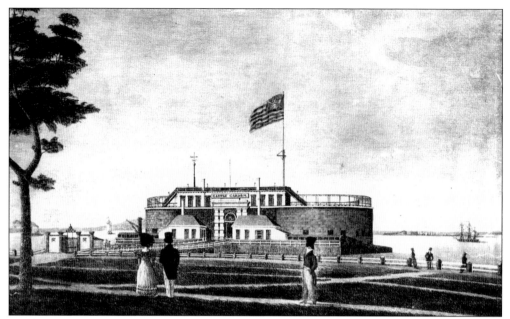

Castle Clinton, the most reused of the forts, was transformed from its original military purpose into a concert hall, immigration station, aquarium, ruin, and national monument. At this location, around 1825, the Castle Garden auditorium was the largest enclosed space in the country. Fill from harbor dredging and building construction was dumped into the water to extend the tip of Manhattan and put the fort at its shore. (EI.)

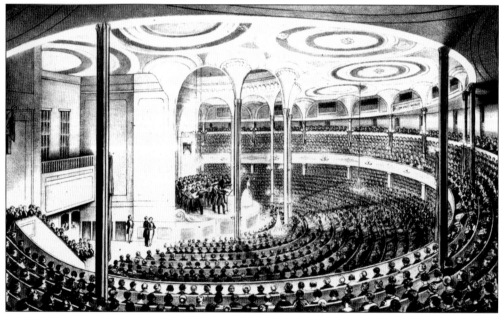

Jenny Lind, a famous opera singer, gave her first American concert at Castle Garden in 1850. This drawing depicts that formal evening and shows what had been built inside Castle Clinton in 1824. The curved part of the fort faces the water. The hall was lit by gas and by windows atop the gallery and in the cupola. A banner reads, "Welcome, Sweet Warbler," as Lind was known as "the Swedish Nightingale." (EI.)

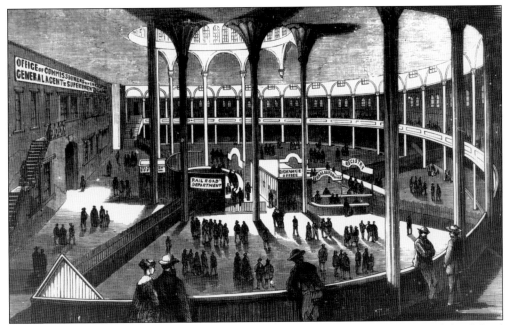

The Emigrant Landing Depot was operated inside Castle Clinton from 1855 until the federal government took over this state responsibility and opened Ellis Island in 1892. Eight million immigrants, who arrived by ship and landed on nearby docks, were processed here. The two-story officers' quarters of the old fort is on the left. The floor, the old parade of the fort, was usually crowded with families and with agents selling passage on the Erie Canal, which was built under Governor Clinton. (EI.)

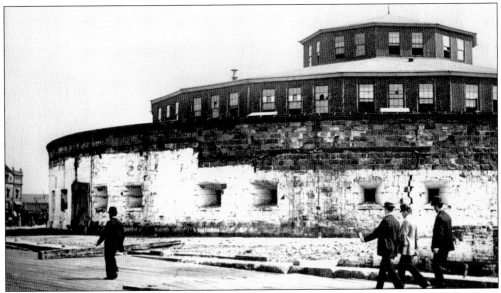

Derelict when this 1892 photograph was taken, Castle Clinton gained a new life as New York City's aquarium. Closed in 1941 with the advent of war, the fort was nearly demolished in the 1950s by Robert Moses, who planned roadways here. Only parts of the walls were left standing when Congress saved the fort from becoming rubble. Castle Clinton's location, history, and adaptability kept it from destruction several times in 200 years. (EI.)

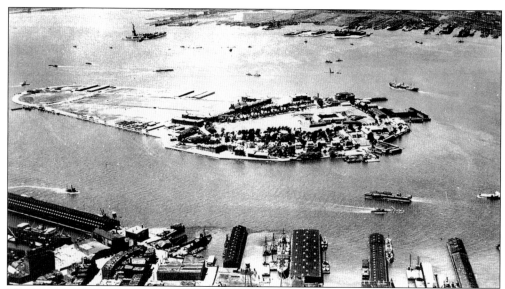

The location of Governors Island made it ideal for fortifications. Star-shaped Fort Jay, begun in 1794 because a war with France was anticipated, was rebuilt in 1806 for a possible war with England. Castle Williams was completed in 1811 and, with Castle Clinton, defended the 3,000-foot channel. This 1920 photograph shows the airfield from which Wilbur Wright took off to fly around the Statue of Liberty. It was the site of a World War I aviation training center. (EI.)

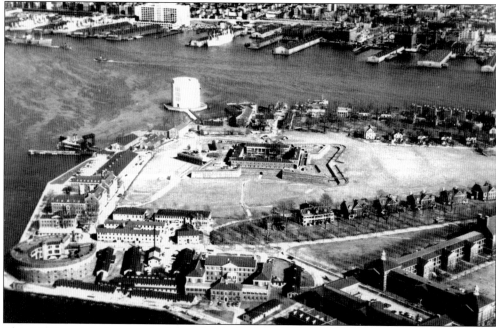

This 1970s aerial photograph shows Castle Williams at the left and Fort Jay on the island's highest elevation. The modern structure in Buttermilk Channel is a ventilation tower for the Brooklyn-Battery Tunnel. During the Civil War, while the post's garrison was in Manhattan to help quell draft riots in 1863, some rioters attempted to attack the island to obtain weapons stored there. They were repulsed by civilian arsenal workers who armed themselves to keep rioters from landing. (GN.)

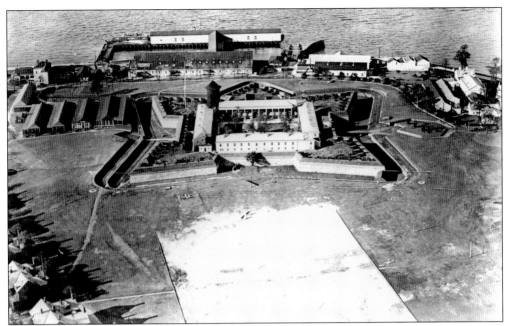

This 1922 view shows Fort Jay's land defenses. A dry moat, spanned by a drawbridge, surrounds the walls. Pointed bastions mount swivel guns to fire along the walls of two adjacent bastions. The earth behind the thick sandstone absorbed the impact of cannonballs. Large 1840s barracks were built inside on the parade; a later addition was the post's water tank. A tunnel, now blocked, leads from the fort to Castle Williams. (GN.)

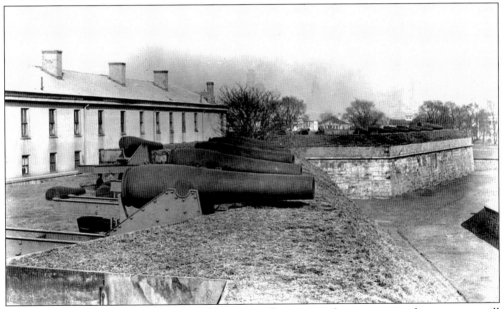

The fort's last armament was 100 Rodman guns firing over the parapet, and most were still in place in 1934. The aiming of these guns was not precise, as they were sighted along their barrels at moving targets; therefore, many of them were fired at the same time so that some cannonballs would hit. The 300-pound balls were stacked behind the guns, but powder was stored below in earth-covered magazines. (GN.)

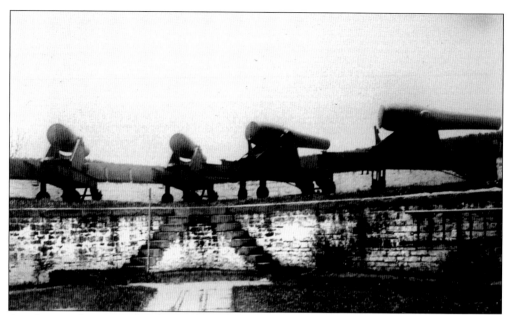

Another emplacement, South Battery, was erected in 1812 on Buttermilk Channel to prevent ships from bombarding the other forts or landing troops. Seen in the 1890s, its guns could fire over its sandstone walls along the channel or across its 1,500-foot width. Solid cannonballs were often heated until red hot to set wooden ships alight. An officers club was built over this battery, and its walls and two barbette emplacements can be seen in the cellar. (GN.)

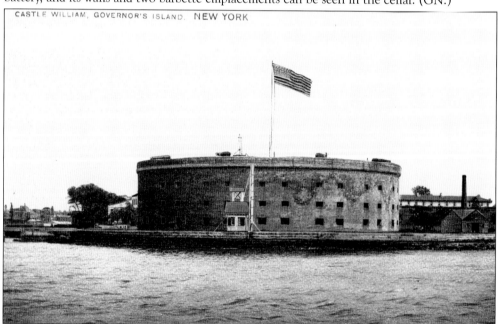

CASTLE WILLIAM, GOVERNOR'S ISLAND. NEW YORK

Castle Williams is seen from the water around 1900. With a diameter of 200 feet, its 40-foot sandstone walls are 8 feet thick. It mounted 26 guns firing 35-pound balls on each casemated tier, and 10- and 15-inch Rodmans firing 125- and 300-pound balls on the upper level. The outer wall is laid with dovetailed stone blocks, which were hand-chiseled to fit so that none could be removed without first being smashed. (RD.)

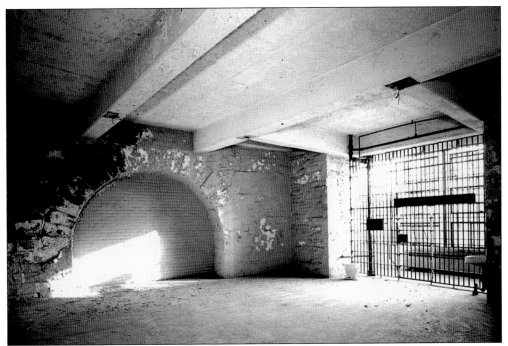

Castle Williams was used as a prison for Confederate soldiers, and 1,500 officers and men were held here. Walls were built at the rear of the gun casemates overlooking the open yard, and stairs and passages were closed with iron grilles or brick. In 1922, it became an army prison and was in use through 1944. One of the casemates for groups of men is seen in this 1950s photograph. The blocked archway once led to the adjacent casemate. (NA.)

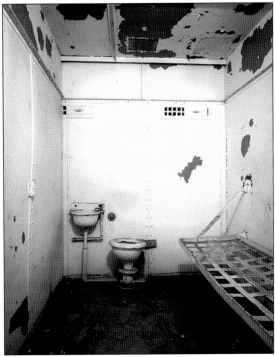

All forts had guardhouses, which were similar to civilian police stations. The largest cell there was the "drunk tank," and soldiers who became unruly in town and were gathered up by the military police spent the night inside it. Castle Williams, like the guardhouses, also had isolation cells for violent soldiers, or for those who had escaped or were being punished. Its bleak appearance must have deterred men from visiting too often. (NA.)

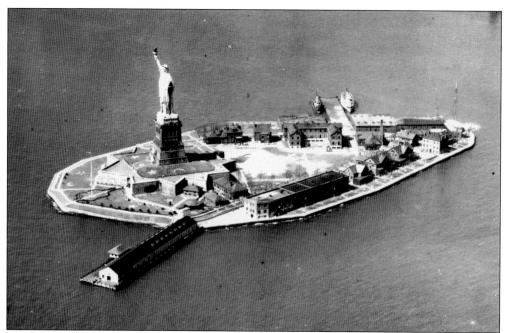

The Statue of Liberty was placed on a pedestal atop Fort Wood, an 11-pointed star-shaped fort begun in 1808. Earlier, Bedloe's Island was a farm, prison, hospital, and quarantine station. Its present use began when the Statue of Liberty was dedicated in 1886, but the army retained the rest of the 12 acres, using the cantonment buildings they had started in 1877 as a recruiting depot and Signal Corps school, seen in this 1932 aerial view. (EI.)

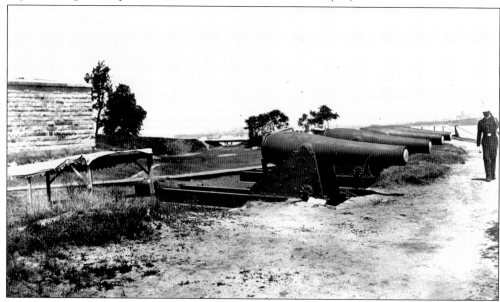

Waterside batteries increased Fort Wood's ability to deter enemies from the bay. These 8-inch Rodmans, placed low near the water, could be fired so as to skip a cannonball along its surface, much as one can skip a stone over the surface of a lake. Seen in the 1890s, these guns were removed after modern ordnance was emplaced at the Narrows. A sentry walks his lonely post around the island. (NA.)

Garrison Quarters
Bedloes Island
1864

These soldiers at Fort Wood's barracks were quartered here in 1864 to man their guns if a Confederate privateer slipped past patrolling navy ships to raid Union commerce. They also guarded 100 sick Confederate prisoners. The fort's 20-foot-thick walls mounted 77 guns, guarding the harbor and, with its pointed bastions, protecting the fort itself. It was named for Lt. Col. Eleazer Wood, who was killed in the War of 1812. (NA.)

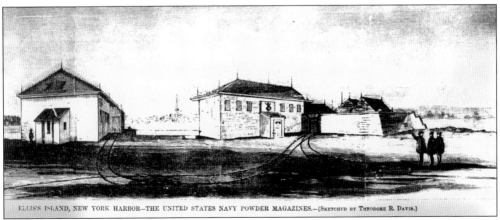

ELLIS'S ISLAND, NEW YORK HARBOR—THE UNITED STATES NAVY POWDER MAGAZINES.—[SKETCHED BY THEODORE R. DAVIS.]

The federal government purchased Ellis Island in 1808 and built Fort Gibson, a single-tiered, semicircular stone battery for 14 guns. On 3 acres of unstable sand, no heavier construction was possible. A shot furnace and a barracks were also constructed. In the Civil War, while the army manned the guns, the navy built magazines to stockpile gunpowder. They left in 1890, amid fear of possible explosions, and the island's first immigration station followed. (EI.)

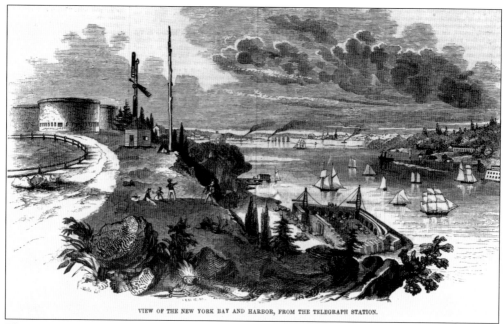

VIEW OF THE NEW YORK BAY AND HARBOR, FROM THE TELEGRAPH STATION.

The Narrows was the most important site in the 19th century for denying an enemy the inner bay, and this 1852 drawing shows some of the construction being undertaken then. Atop the cliff on Staten Island is Fort Tompkins, built in 1812 and replaced by a larger fort with the same name in 1858. Battery Weed is being raised at the water's edge. Fort Lafayette, built in 1812, is on the far side of the channel, and on shore is Fort Hamilton, built in 1825. (NA.)

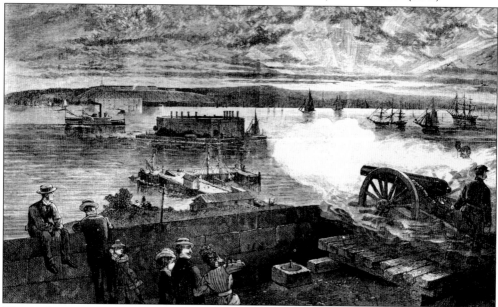

The traditional sunset gun, with no cannonball, is being fired from a field gun on Fort Hamilton's parapet in this 1879 drawing. Fort Lafayette is on Hendrick's Reef offshore, being passed by a side paddlewheel steamboat, soon to replace sailing ships in the harbor. On the Staten Island side is Battery Weed and the new Fort Tompkins above it. The loungers are enjoying a great view. (NA.)

Three
CLOSING THE NARROWS

By the early 19th century, the emphasis on defending New York's harbor shifted from the inner bay to the Narrows. While the island forts continued to serve, most of the next generation of fortifications was built at the Narrows and at the entrance from Long Island Sound. The Narrows had been the site of Dutch and Revolutionary War batteries, and masonry batteries were built in 1808–1809 on the Staten Island side. New York State took over the site in 1813 and built other works here, but while they were of sandstone, they were not built for longevity. After the War of 1812, a major program was begun by the federal government to build a permanent system of large masonry forts, and more than 30 works were built around the country from 1821 to 1864.

On Staten Island, the first major work was Fort Richmond. It was constructed at the water's edge from 1847 to 1860. Above it was Fort Tompkins, constructed between 1858 and 1864. A detached work known as Battery Hudson was also built in the 1820s. On the eastern side was Fort Lafayette, started in 1812 and finished in 1822. The major Brooklyn work was Fort Hamilton in New Utrecht, built from 1825 to 1830. Finally, a massive new casemated work was started at Sandy Hook in 1860 but was never completed due to the Civil War. These granite forts were some of the finest examples of American military architecture, and fortunately most still exist today.

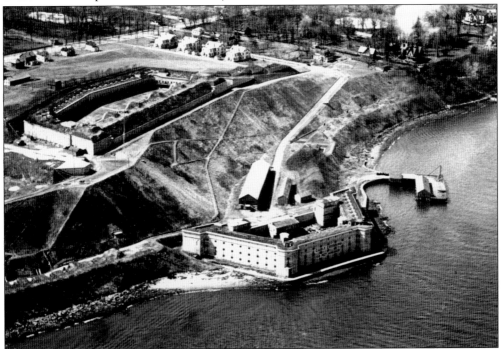

The western side of the Narrows has been an actively defended site since the 1700s. Six significant fortifications were built here from 1808 to 1813, one often replacing an older version. The last and most sophisticated enclosed works were begun in what was called the Third System: Fort Richmond (at the water's edge), started in 1847, and Fort Tompkins (on the bluff above and behind Richmond), started in 1858. (GN.)

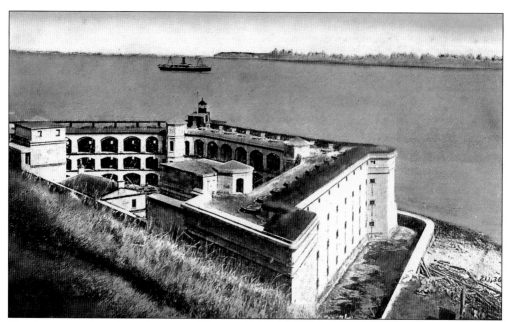

This is a good view from the rear of Fort Richmond. Designed for three casemated levels and a top barbette tier with bastions at the corners, the full armament, although never completely mounted, would have been 140 guns. The work was renamed Fort Wadsworth in 1865. It was referred to as Battery Weed from 1902, when the Wadsworth name was used to describe the entire reservation. (KS.)

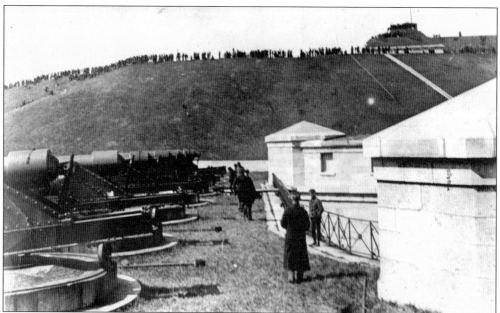

This photograph taken in the late 19th century shows the top, or barbette, tier of the gun emplacements at Fort Wadsworth. The weapons mounted are Parrott rifles of Civil War vintage. Note the flagpole on Fort Tompkins on the hill behind Wadsworth and the large number of soldiers watching from the hilltop. Practice firing may have been about to begin, as there are rammers next to the guns. (GN.)

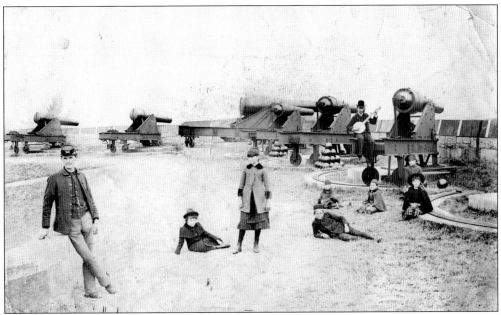

This is another post–Civil War photograph taken atop Battery Wadsworth. Soldiers and their friends and family are relaxing on the barbette tier, or parapet, of the fort while one plays a banjo. This relaxed scene is typical of this time, as the picturesque forts often overlooked some of the best views in the harbor and thus became popular Sunday and holiday destinations. (GN.)

Soldiers billeted in Fort Tompkins's barracks are lined up for inspection on its interior parade ground in the 1890s. Construction of Fort Tompkins began in 1858; it replaced an 1812 fort on the same site and was intended primarily to provide protection from land attack against Battery Weed below. Although its guns were removed, the fort was used as housing and storage for over 100 years. Earth-covered magazines for guns mounted on the parapet are atop the walls. (GN.)

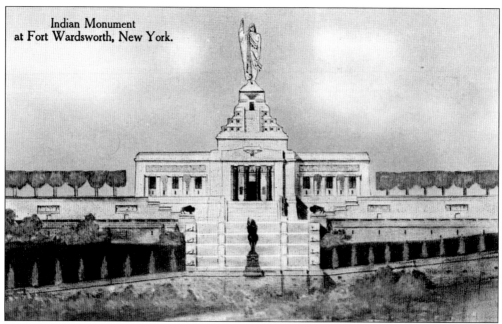

Indian Monument
at Fort Wardsworth, New York.

A Native American monument was once planned for the top of Fort Tompkins. The idea of John Wanamaker (of department store fame), the memorial was intended to commemorate the first inhabitants of America and the first people to settle near New York's harbor. Ground was broken in 1912 by President Taft, but difficulties in raising money and the coming of World War I prevented the memorial from ever being built. (GN.)

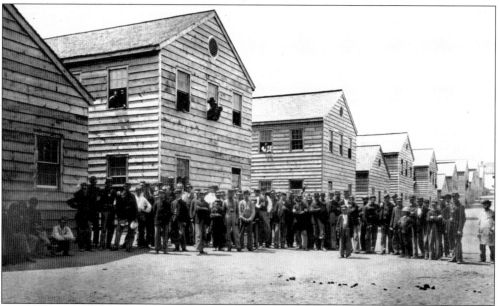

All of the fortified harbor sites had quarters for permanently assigned garrison troops, and because of their location near the port, many also housed soldiers due to board ships taking them to battle areas. This 1864 Civil War photograph shows part of a unit outside their unpainted wooden barracks on the Fort Richmond reservation. Several of them are young drummer boys, indicating these soldiers will probably soon see combat. (NA.)

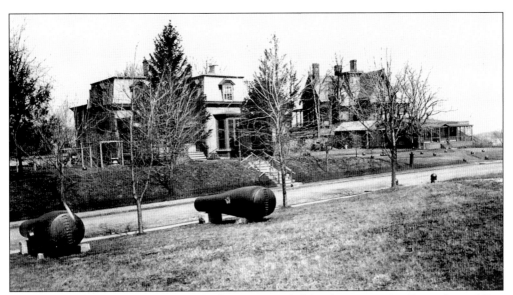

Quarters of significantly higher standards were provided for the garrison's officers. Part of Fort Wadsworth's "Officers' Row" is shown in the 1880s with the commanding officer's residence on the right, overlooking the Narrows, and two Rodman cannons removed from Battery Weed displayed in the foreground. In a new process, iron Rodman guns that had just been cast were cooled by water from the inside rather than from the outside, as was done earlier, greatly strengthening them. (NA.)

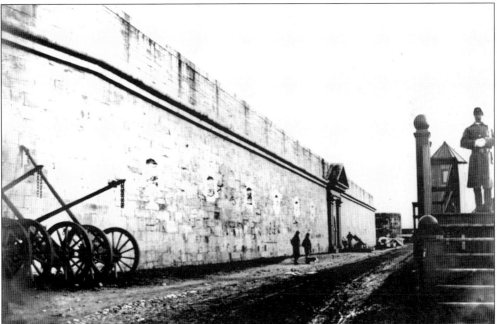

Complementing Fort Wadsworth, Fort Hamilton was built on the eastern side of the Narrows. Land was purchased in 1824, construction took place between 1825 and 1830, and the first troops were garrisoned there in 1831. This 1875 photograph shows a sentry on a platform to the right of the work's main sally port. An additional entry at the rear of the fort was protected by a small triangular caponier outwork in the dry ditch, now an army museum. (HM.)

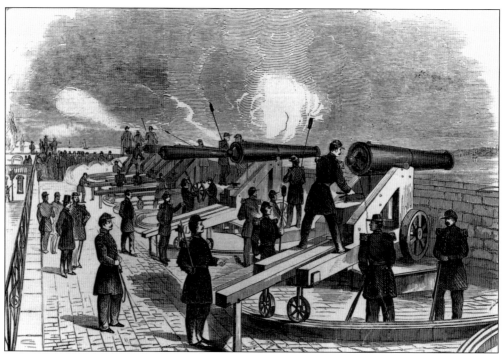

Hamilton's design called for thirty-eight parapet guns, fourteen more below in seafront casemates, and fourteen 24-pound flank howitzers. This 1860 illustration from *Gleason's Pictorial* shows the City Guard under the command of Captain Lovell practicing loading, aiming, and firing their parapet-mounted seacoast cannons. The guns rotated about a center pintle, the rear wheels of their wooden carriages rolling on metal rails set atop curving granite blocks. (HM.)

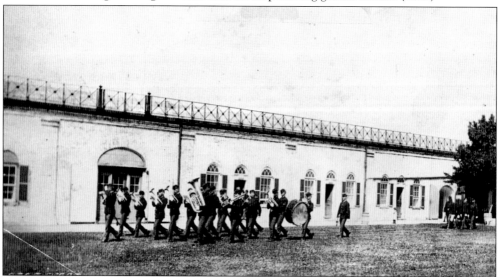

This is the interior parade ground of Fort Hamilton. Shown is the inside entry to the main sally port; the exterior is shown on page 29. Typically, the casemates pointing toward the ocean were reserved for large gun mountings, and those on the inside wall were used for offices, storage, and officers' quarters. In northern forts, all were protected from the weather with rear walls. This 1875 photograph shows the post band marching by the sally port. (HM.)

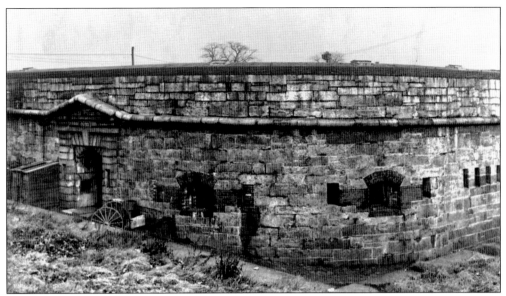

Fort Hamilton was further protected on its land approach by a small separate fortification. This redoubt was built about 1,000 feet to the northeast of the main fort and completed at the same time. It was a simple rectangular work surrounded by a dry ditch with emplacements for both parapet and casemated guns, normally short-range howitzers effective against attacking troops. This 1950s picture shows it used for storage, not long before it was destroyed in 1959. (HM.)

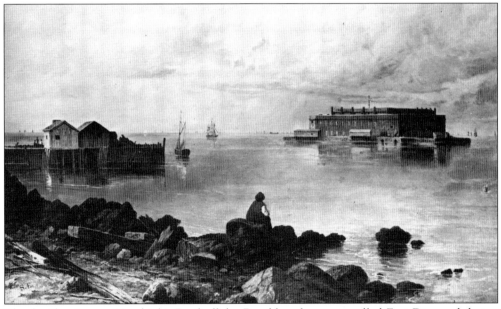

The fortification on Hendrick's Reef off the Brooklyn shore was called Fort Diamond during construction, but when completed in 1823, it was renamed Fort Lafayette. Two layers of casemates held 23 cannons each, in addition to the armament at the barbette level. As the fort was surrounded by water, it obviously needed no ditch for protection. Lafayette was used for storing ammunition unloaded by naval ships going to piers or to the Brooklyn Navy Yard in World War II. (NA.)

A much later view of Fort Lafayette, dating from around 1940, shows a 75mm field gun at Fort Hamilton, probably in use as a ceremonial saluting piece. Lafayette was located on a shoal to the west of the shoreline, an ideal place for the eastern tower of a bridge spanning the Narrows. Across the channel can be seen Battery Weed at Fort Wadsworth on the Staten Island side. (KS.)

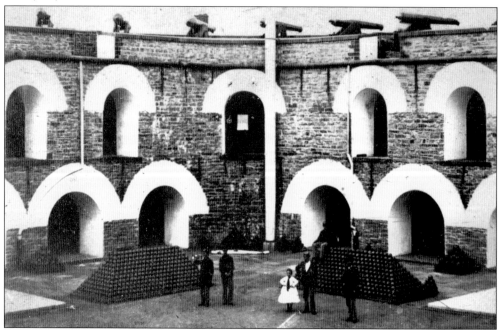

Taken during the Civil War, this photograph of the interior parade of Fort Lafayette shows the unusual offset rear openings to the casemates, with guns mounted on the top barbette tier. Cannon balls were neatly stacked outside (as seen here), but gunpowder was safely stored in protected magazines on each level in the corners of the work. In 1868, Fort Lafayette was abandoned for defensive purposes, and the structure was destroyed in the 1960s for construction of the Verrazano-Narrows Bridge. (HM.)

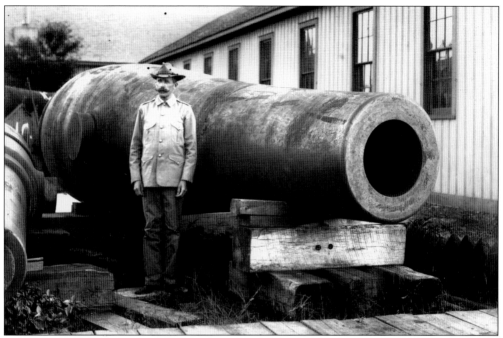

The largest type of gun produced by the United States through the Civil War was the 20-inch Rodman cannon. Only two were used by America, ultimately going to Fort Hamilton and to Sandy Hook. The gun fired a shot weighing 1,080 pounds about 6,000 yards using a 100-pound powder charge. It was the ultimate seacoast weapon of the time and represented the peak of American cast-iron, muzzle-loading technology. Both guns still exist, each displayed at their originally assigned posts. (OM.)

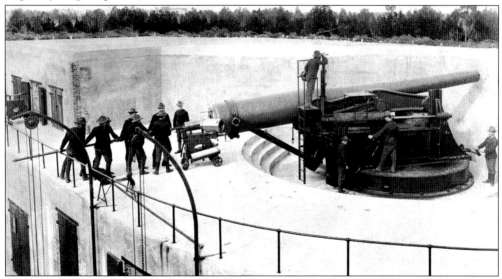

Within 25 years, the technology of gun design and manufacturing had changed dramatically. Also taken at Fort Hancock, this photograph shows a 10-inch model 1888 rifled gun on a disappearing carriage. The tube weighed just over 67,000 pounds and fired a 618-pound shell over 16,000 yards with a much higher muzzle velocity and armor-penetrating ability. Unlike the Rodman above, none of the larger guns like this still exist in the New York forts. (OM.)

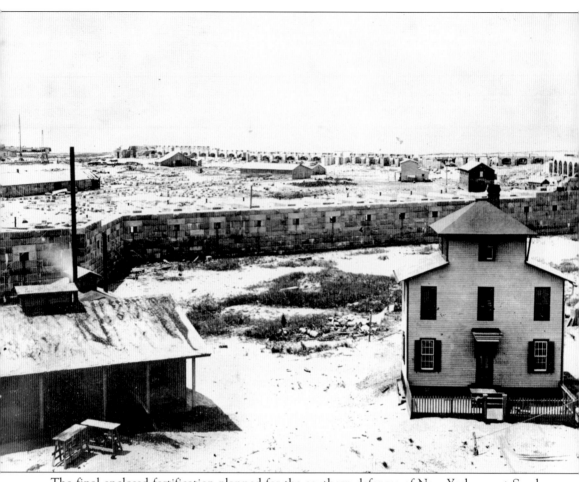

The final enclosed fortification planned for the southern defenses of New York was at Sandy Hook in New Jersey. The fort was designed to cover the main ship channel through the lower bay. Work was not begun until 1859, and the fort was only partially completed when construction ceased in 1869. Much of the granite wall of the first tier was removed prior to 1900. It was never officially named, and just a few partial remains exist at Fort Hancock today. (OM.)

Four

MODERNIZING THE DEFENSES

When the Civil War ended, work on some forts continued, but the vulnerability of masonry forts was obvious. In the 1870s, new batteries were begun, and while never completed or armed, they defined a new style of construction that was to endure. Forts became pieces of real estate rather than distinct defensive structures, and separate batteries were built for a few powerful guns, distributed around the fort's terrain and protected by earth and concrete emplacements. More modern armament—breech-loading, rifled, steel guns on new types of carriages, such as gun-lift, disappearing, masking parapet, pedestal, and mortar—was developed for these batteries. In 1886, Pres. Grover Cleveland commissioned a board chaired by Secretary of War William Endicott to recommend a modern system of national Coast Artillery defense, built during what became known as the "Endicott period."

In Endicott's report, New York City's harbor defenses were ranked as the highest priority in the country. While the original plan changed over the next 20 years, this was always the country's most heavily defended location. Six sites, all of which were existing army reservations, were chosen: three to defend the southern channel—Forts Hamilton, Hancock, and Wadsworth—and three for the eastern entrance—Forts Schuyler, Slocum, and Totten. Sometimes, granite forts and remains of 1870s batteries were modified for the new armament; in other cases, they were destroyed to make room. An elaborate support system of fire control stations, electricity-generating powerhouses, telephone switchboards, electric searchlights, and submarine mining defenses accompanied the new works. Finally the posts themselves became cantonments for large numbers of Coast Artillery Corps troops. In fact, in 1907, the corps became a separate command within the U.S. Army, one of its largest and best-equipped branches.

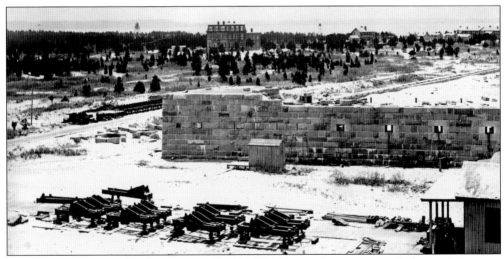

An important 1874 development at Sandy Hook was the creation of the army's major ordnance-testing establishment (initially located near the walls of the old incomplete fortification). There, the army tested new domestic and foreign-produced cannon and gun carriages for American service. The Ordnance Department's Proving Ground was organized and commanded separately from the Fort Hancock coastal defense fort. Here, carriages near the old walls await guns to be test-fired from them. (OM.)

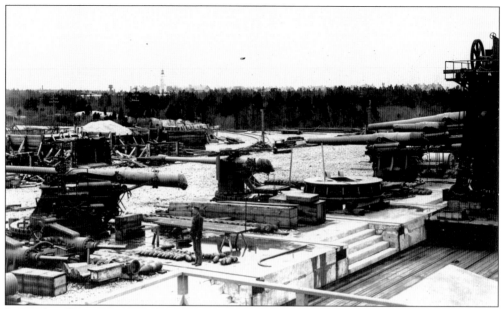

It was found necessary to relocate the testing gun line of the Sandy Hook Proving Ground around 1900. A long concrete platform was built to hold carriages and guns firing south along the beach. Two primary tasks were accomplished here: the test firing, or proofing, of each newly made major gun tube and the testing or evaluation of experimental, prototype, or foreign-produced guns. The Proving Ground remained here until it was relocated to Aberdeen, Maryland, after World War I. (OM.)

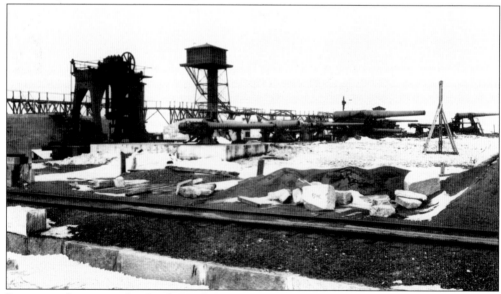

Prominent features at the Sandy Hook Proving Ground's gun line were an observation tower and an immense gantry crane. This crane was used to transport gun tubes and heavier sections of gun carriages to various firing platforms directly from railcars or nearby storage parks. A powder laboratory and a chronometer timing building were also built. Thousands of gun tubes went through the proofing process here and on occasion were found wanting, experiencing disastrous and often explosive failure. (OM.)

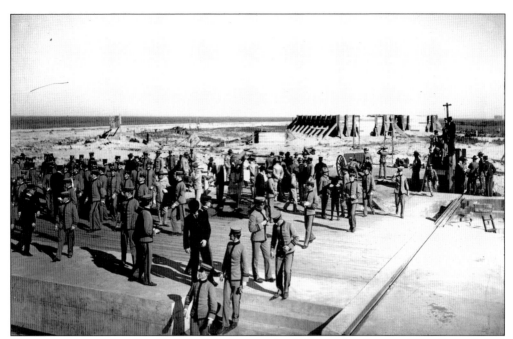

The proximity of the New York harbor forts to the Military Academy at West Point led to numerous visits by cadets to enable them to study modern ordnance characteristics. In this early-1900s photograph, the cadets are congregating around a gun on its platform at the proofing gun line. In the distance, one of the targets for armor-penetration tests can be seen. (OM.)

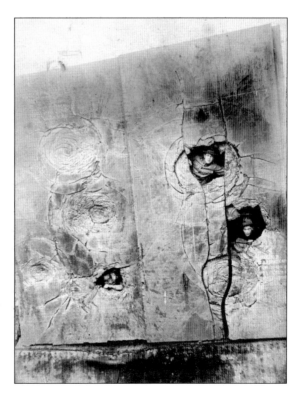

Tests of the penetration capabilities of various guns and shell types were routinely conducted at the Sandy Hook Proving Ground. This early-1900s photograph shows holes made in a test piece of armor plate. Soldiers are posing for the photograph by sticking their heads through the various hits. The emerging technology of steel armor plate and high-velocity guns led to an ongoing process of test evaluation from 1890 to 1918 and resulted in improvements to seacoast artillery weapons. (BS.)

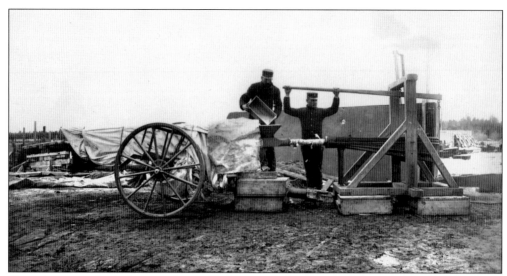

Operating a technical research establishment such as the Proving Ground involved a considerable amount of maintenance and repair. This early-1900s photograph shows an early method of sandblasting rust from metal parts by using a large manually powered bellows to blow abrasive on the part. Under the tarpaulin that catches the sand is some heavy carriage part or ordnance tool resting in a wagon or a gun limber, and it is most likely being cleaned prior to repainting. (OM.)

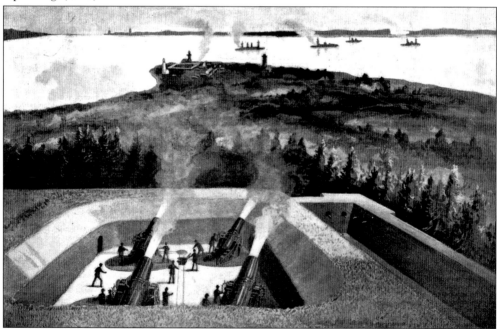

In 1890, funds for modernizing American coastal defenses were appropriated. Included was $201,000 for a mortar battery at Fort Hancock. Four pits at the corners of a square, each mounting four mortars, were built between 1891 and 1894. This 1898 *Scientific American* drawing, while not accurate in fine details, shows one pit, the walled ditch around the battery for land defense, the old fort at Sandy Hook's tip, and enemy ships in the lower bay being successfully hit. (OM.)

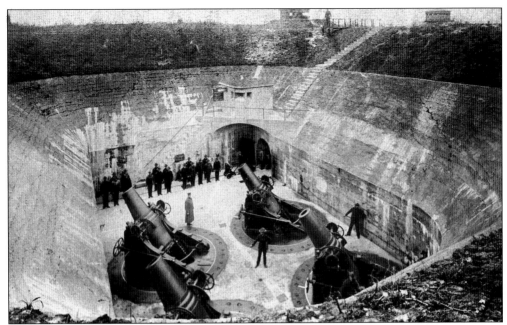

Battery Reynolds was constructed near the Sandy Hook lighthouse. Four of its 16 mortars are shown being raised to their firing positions. Over the concrete and sand protection was the surrounding ditch with machine guns able to fire into it from two corners. The entrance to the magazines and the other pits is near the upper-right mortar. Battery Reynolds remained a key defensive work until World War I and was used in World War II as a command headquarters. (OM.)

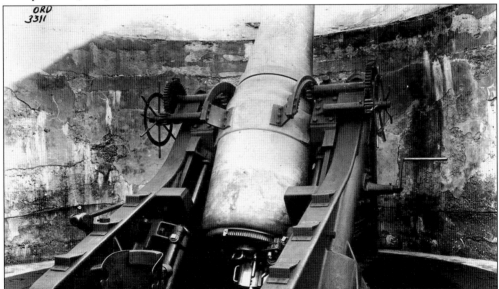

Battery Reynolds, like Fort Slocum's similar Battery Haskins on Davids Island, was armed with the new model 1886 mortar. The gun was built of cast iron with steel hoops and breech, and it could fire a 12-inch-diameter, 1,000-pound shell up to 10,500 yards. A salvo of all 16 mortars was fired, permitting shells to rain down on the relatively weakly armored decks of attacking ships. Later models of such mortars were in active use through World War II. (OM.)

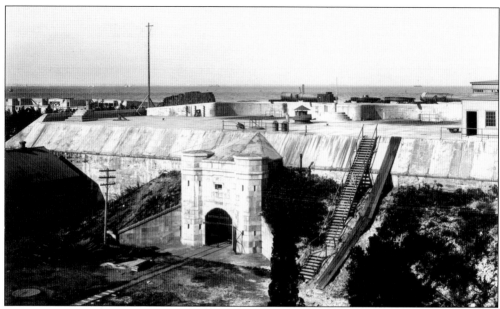

The second battery started at Sandy Hook in 1890 was for two 12-inch guns on lift carriages. A huge three-story structure was built with two steam-powered elevators to raise the guns on their barbette carriages to rooftop firing positions. Named Battery Potter, it was built between 1891 and 1894. The lift design proved too complicated and ultimately unnecessary, and it was not repeated anywhere else. The classic entryway into the battery resembles something from a much earlier time. (SH.)

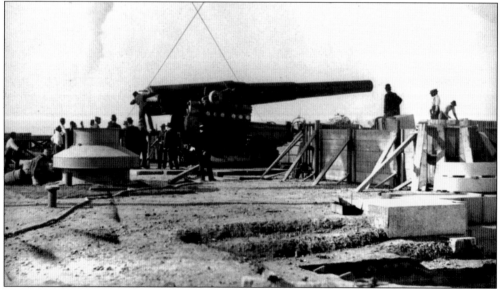

One of Potter's guns is elevated in its firing position with the squat chimney for the lift's boilers on its left. Model 1888 12-inch rifles such as these were often used on disappearing and barbette carriages at coastal forts. The battery was named in 1903 for Brig. Gen. Joseph Porter. Nearly all of the coastal artillery batteries were named for famous army personnel or for officers killed in battle, particularly in the Spanish-American and Philippine War campaigns. (SH.)

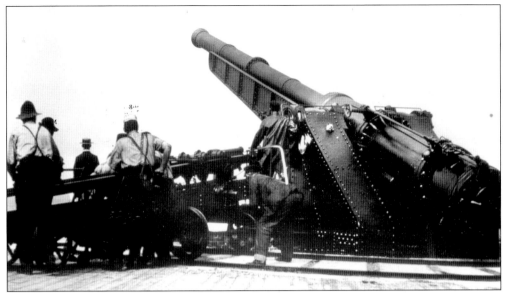

Another early Sandy Hook emplacement was the Dynamite Battery. This new explosive was more destructive than the powder then used in shells, but the concussion of firing could detonate a dynamite-filled shell inside the gun barrel. Compressed air was used, gently blowing the nitroglycerine-filled, dart-shaped missile out while not detonating it. A three-gun emplacement was built between 1889 and 1894, but it was abandoned as impractical by 1902. This is a similar gun at Fisher's Island in Long Island Sound. (SH.)

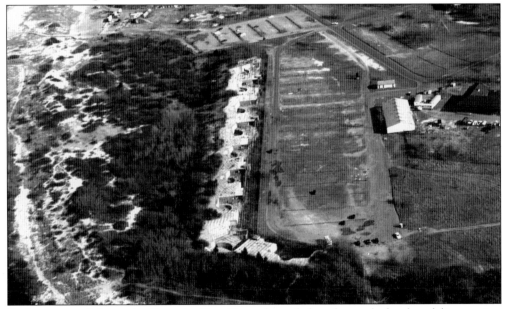

For long-range defense, the Coast Artillery Corps depended on the newly developed disappearing gun. Large batteries holding guns, carriages, ammunition, and command and support rooms were built in emplacements of one to nine positions. The single largest such battery line was built along the old northeastern wall of the Civil War–era work at Fort Hancock. The nine-gun battery can easily be seen in this 1994 aerial photograph. World War II barracks once filled the field to its right. (GW.)

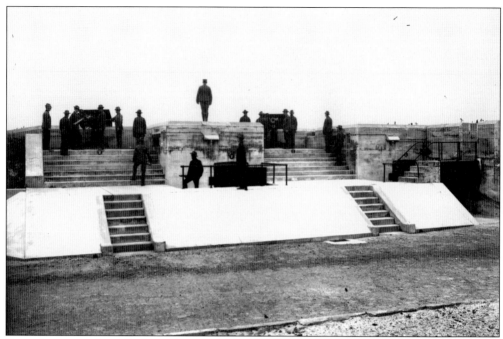

Forts also received smaller batteries intended to cover their mine fields, mainly to prevent their premature clearing by enemy minesweepers. Guns of 3-, 4.7-, 5-, and 6-inch size were employed for this use. Pictured here is part of Battery Urmston at Fort Hancock. This section of the battery was built in 1899–1900, and additional emplacements were added a few years later. The battery served until disarmed in 1920. (OM.)

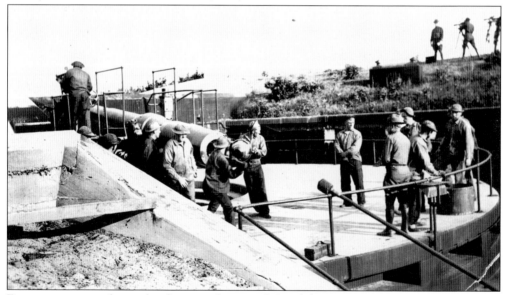

Extensive use was also made of intermediate-sized 6-inch batteries to provide protection from smaller enemy vessels and to give flank protection at the sides of the fields of fire of larger guns. This is one of the two disappearing guns of Fort Hancock's Battery Gunnison in 1932 during a loading drill. It was built in 1903–1904 and manned through World War II, although it had a change in armament type in 1943. (SH.)

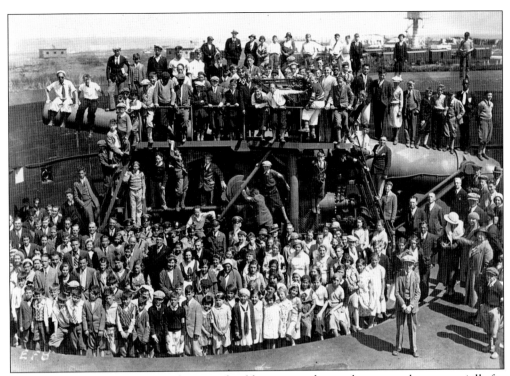

The larger disappearing guns took a considerable crew to adequately operate them, especially for continuous ammunition service. Their long barrels, relatively complicated large carriages, and spacious loading platforms also seemed to be irresistible locations for taking group photographs. Postcards and soldiers' snapshots of the period often show such guns crowded with people, as this 1930s view does of one of the positions in Hancock's nine-gun battery. (SH.)

Fort Hancock was named in 1895 for Gen. Winfield Scott Hancock, who distinguished himself when his troops held the center of the Union line during Pickett's charge at Gettysburg. Its large, well-equipped reservation was often used for training exercises, both for the resident Coast Artillery garrison and for visiting units. This 1910 photograph shows troops preparing for small arms target practice at the fort's firing range near the beach. (BS.)

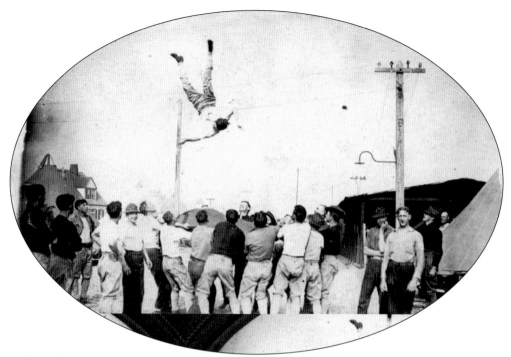

Soldiers did not spend all of their time at the coastal forts in work or training. Their candid photographs usually show a more relaxed and humorous side of garrison life and would be the type mostly sent home to their families. Here, some of Hancock's troops are practicing a blanket toss around 1910. (BS.)

This posed photograph, taken in 1909 at Fort Hancock, is entitled "Called Away." It shows an officer kissing his wife good-bye prior to moving off with his unit. In a few more years, this activity would not have to be staged, and it would certainly be much more fraught with anxiety as soldiers would then be going into battle, not lined up for a photograph or leaving for training. (KS.)

The quality of enlisted men's accommodations varied in the pre–World War I army. New York's long-established large Coast Artillery posts had fine barracks and other cantonment facilities; Fort Hancock's barracks buildings were typical of those at other permanent army posts. This 1903 photograph shows soldiers relaxing and cleaning their rifles, kept unloaded in the locked racks in the center aisle. Well-shined boots and shoes are lined up at the foot of the beds. (SH.)

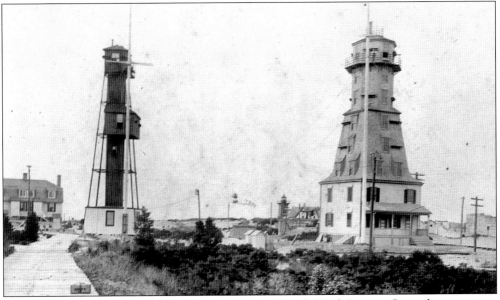

Numerous towers were built on the Fort Hancock and Sandy Hook Proving Ground reservations. In addition to the Coast Artillery's fire control stations for the long-range defensive guns and mortars, an observation tower and the Western Union signal tower, which telegraphed ship arrivals to New York City companies, were located near the beach in the early 1900s. Neither remains today. (OM.)

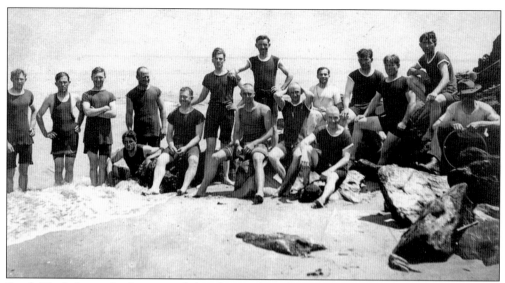

Sandy Hook does indeed sport sandy beaches, and sand piled in front of the gun batteries helped conceal and protect them. For hundreds of years, the location has been a valued swimming, sunbathing, and fishing site and was certainly utilized by the post garrison for those purposes. This 1910 postcard shows some of them wearing their two-piece bathing suits. The beach was constantly eroded over the years, and the fort became an island whenever storms breached its narrow peninsula. (BS.)

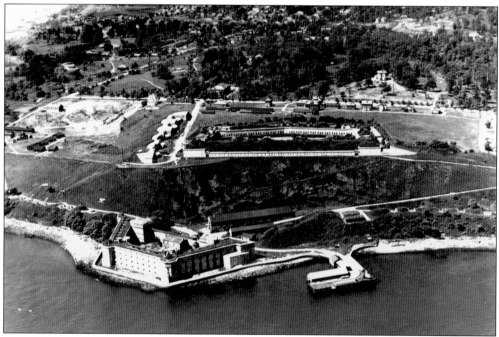

In 1890, work began on installing modern armament at Fort Wadsworth, actually still Fort Tompkins until the reservation's name was changed in 1902. In the left center of this 1923 aerial photograph are five emplacements for the 8-inch disappearing guns of Battery Duane, the first new battery undertaken here. Instead of firing into the channel, its long-range guns aimed toward the outer bay. A wharf for the ships that placed underwater mines is near the shore. (GN.)

Additional land adjacent to Wadsworth was acquired for building six two-gun, 10- and 12-inch disappearing batteries firing to the southeast into the outer bay, and their construction was accomplished between 1892 and 1902. This 1908 photograph shows Battery Barry for two 10-inch guns and was taken after completion of an elevated battery commander's station to the battery's rear. Its left gun is raised to the firing position; the lowered right one is hidden by the battery commander's structure. (GN.)

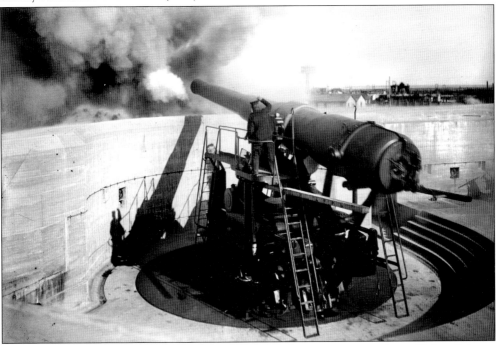

This photograph shows of one of New York's 10-inch disappearing guns firing. Before firing, a large iron counterweight was lowered into a pit, raising the gun above the parapet. Firing caused it to recoil back and down into its loading position. The gun was exposed to an enemy ship only briefly while firing and was out of view and danger during its reloading phase. More than 50 such weapons were emplaced around the harbor during the Endicott period. (SH.)

47

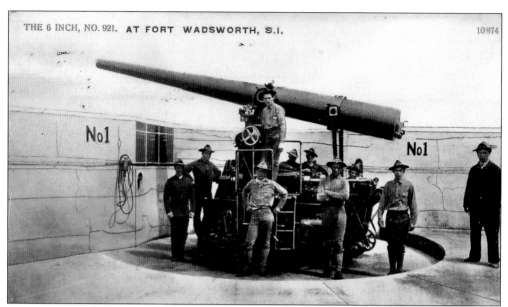

The smallest disappearing carriages were used for 6-inch guns. This 1912 photograph shows the gun crew at emplacement No. 1 of Battery Mills. Guns of a particular battery were numbered from right to left as one faced the enemy. This is the right-hand gun of the two that were in Mills. If the gun was raised in practice without firing, there would be no recoil motion to lower it, so soldiers would have to winch up the heavy counterweight. (KS.)

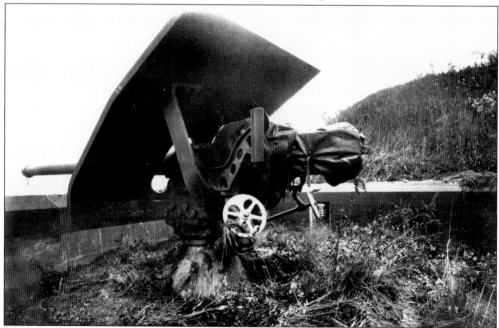

This is one of Fort Wadsworth's smaller 3-inch pedestal guns. Fourteen such guns of three different models were emplaced along the Narrows to help protect the offshore minefields. This is probably one of Battery Turnbull's guns in the period between the world wars when the garrison was reduced to caretaker status. The breech has been wrapped to protect it from the weather, but it seems that some basic brush cutting is also needed. (SH.)

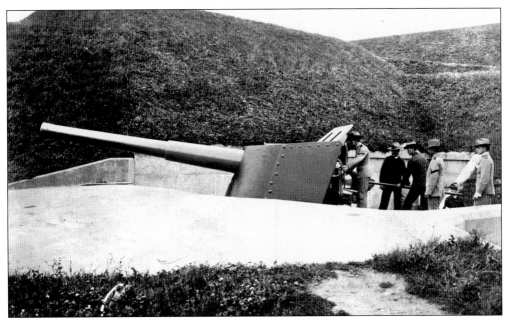

This 1902 photograph shows one of the more unusual weapons used at Fort Wadsworth. During the panic at the start of the Spanish-American War, when each eastern city demanded more coastal armaments, the army purchased some light, rapid-fire guns abroad. This is a 6-inch British-made Armstrong gun hurriedly emplaced on a 1870s Rodman gun platform, using the old adjacent magazine. Only eight such guns were bought, and two were emplaced at the Narrows. (GN.)

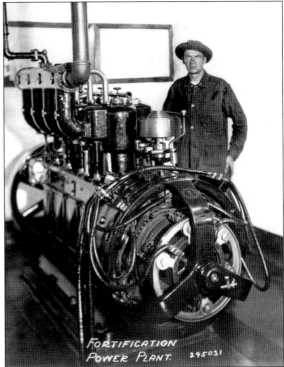

For wartime and emergency use, large gun batteries contained power-generating plants, which produced electricity for lighting and for operating the hoists that raised shells to the gun level. These usually consisted of one or more 25-kilowatt gasoline-engine-powered generators installed in a room in or near the battery. In peacetime, commercial power or the fort's central electrical plant was used. This 1932 photograph shows a soldier standing by a generator during one of the frequent tests. (GN.)

49

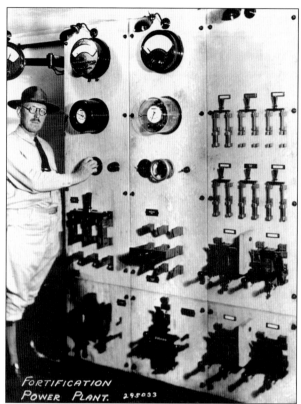

Near the power rooms were electrical switchboards controlling the generators and distributing their electricity to various motors and lights and to other nearby gun batteries. One board at Fort Wadsworth is shown in 1932 with a post electrician adjusting the voltage at one of the two generator control panels. The battery plants also supplied power for searchlights, fire control stations, plotting rooms, and telephone switchboards through underground cables. (GN.)

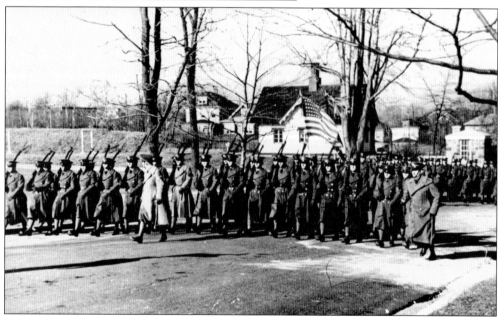

Among the routine post activities were frequent practices in soldierly drilling and marching. In this photograph (obviously taken during the winter), soldiers are marching along one of Fort Wadsworth's main boulevards with the American flag in the 1930s, perhaps returning from a parade in a local Staten Island town. (GN.)

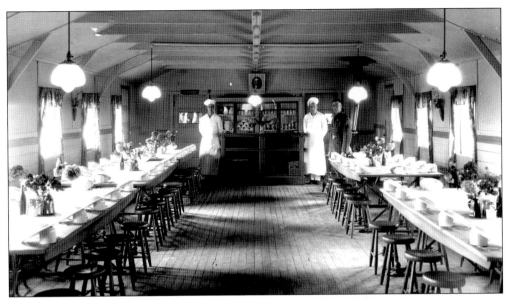

This is a typical 1931 dining hall, with two company cooks and the mess sergeant awaiting the arrival of their hungry customers. Places have been set with dinner plate rims resting on upturned coffee cups. During World War II, compartmented food trays of Bakelite or metal were supplied to mess halls instead of plates, but the thick coffee cups continued in use. A portrait of George Washington hangs above the china cabinet on the far wall. (GN.)

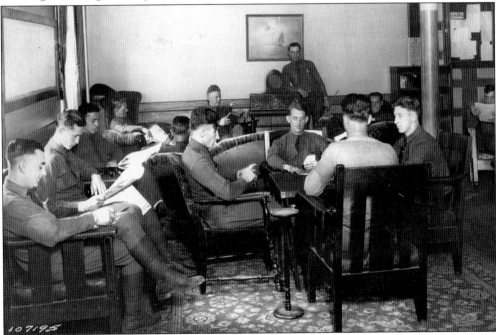

Soldiers are reading, playing cards, and listening to the radio in their company barrack's dayroom at Fort Wadsworth in the early 1930s. The dayroom was a soldier's living room and provided him with a comfortable place to sit, smoke, and exchange rumors in the evenings and weekends. Swearing was sometimes discouraged there by establishing a refreshments kitty, and each profane word uttered would cost the offender a nickel donation. (GN.)

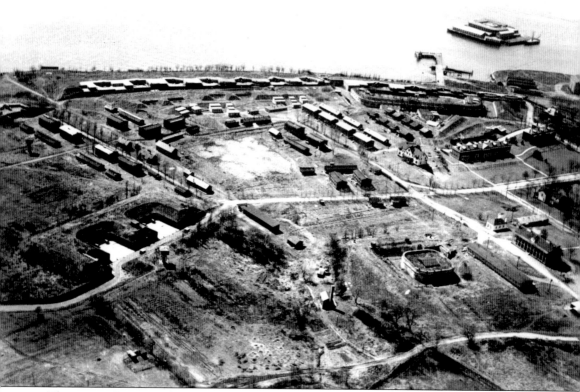

The post at Fort Hamilton is seen from the air in 1923. Like Wadsworth and Hancock, this fort figured heavily in the modernization of the harbor defenses of New York's bays. Between 1892 and 1905, eleven new batteries were built along the water at this site. Heavy and light guns protected the ship channel, and another mortar battery complemented the one at Fort Hancock. Its two pits, once emplacing eight mortars, are seen clearly in the left center of the photograph, while in the right center is the redoubt. Because pits fully armed with four mortars were too crowded for efficient loading, the two rear ones were removed from each pit. At old Fort Lafayette offshore, mostly abandoned since a fire in 1868, an early submarine mine control structure was built into a casemate. (NA.)

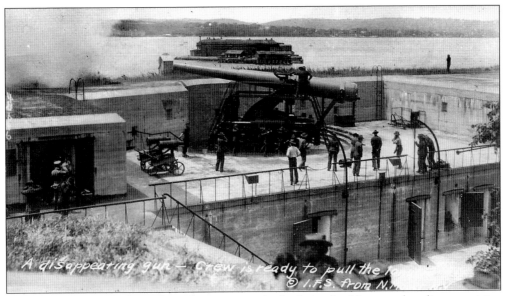

A disappearing gun — Crew is ready to pull the l... © I.F.S. from N.Y.

Fort Hamilton's main line of gun batteries was built along the Narrows shoreline, requiring demolition of the front casemates of the old masonry fort. This early-20th-century view shows one 12-inch disappearing gun of Battery Brown. The weapon is in its raised position, just prior to one of the crew pulling its firing lanyard, and two practice shells are on shot carts to its left. Directly beyond the gun, Fort Lafayette can be seen offshore. (KS.)

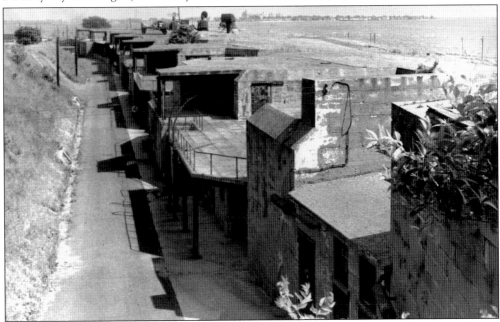

The guns in these Endicott emplacements were removed over time, significant reductions coming in 1917 and 1918, and again in World War II, when more modern long-range batteries at Forts Hancock and Tilden and at Navesink Highlands supplanted older weapons. This is Battery Gillmore at Fort Hamilton, once containing four 10-inch disappearing guns, standing empty and abandoned in the late 1950s before its destruction to make room for new post housing units. (HM.)

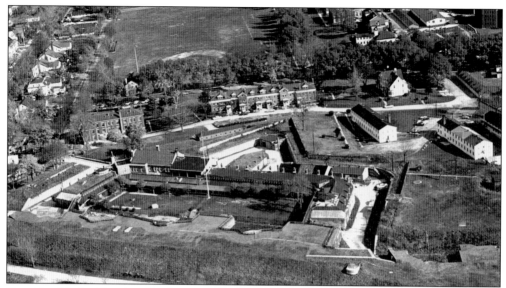

Considerable fortification details are visible in this 1955 Hamilton photograph, taken from just over the shore. The Third System work and its dry ditch are in the center, with the triangular caponier immediately beyond. In front are the outlines of Batteries Burke, Johnson, Brown, and part of Gillmore, although all are empty of armament at this late date. Wooden World War II barracks stand near older brick quarters for the former Coast Artillery garrison, and the parade field is beyond them. (HM.)

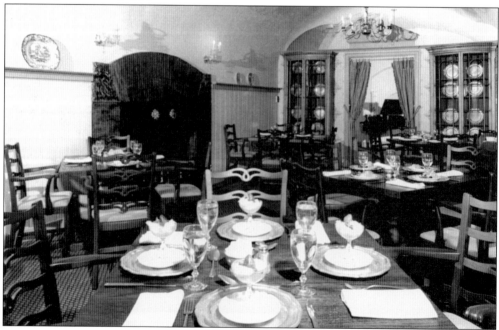

In later years, the casemated gun rooms of old Fort Hamilton were used for other purposes, such as quarters and storage. Eventually, the post's officers club was located here and, much enlarged, is still open as a community facility. This 1950s photograph shows dining tables in one of the barrel-vaulted casemates occupied by the club. The fireplace, once used to heat the casemate when it was quarters, now provides warmth and charm for wintertime diners. (HM.)

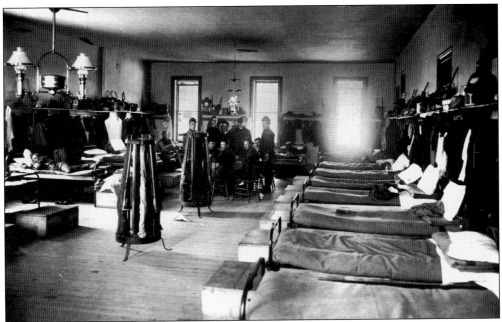

This is a candid shot of the interior of one of the four large dormitory rooms in a Fort Hamilton enlisted men's barracks in 1904. Note the neatly made beds, rifle stands, footlockers, and kerosene lamps. It is an interesting comparison to the larger Fort Hancock barracks interior shown on page 45, where wall lockers are available instead of the clothes hooks and shelving lining the walls here. (HM.)

The major guns at these forts had fire direction provided by dispersed fire control stations. These were small rooms equipped with optical instruments used in conjunction with a plotting room to measure the azimuth and distance to an enemy target. Stations were assigned to a specific battery but could serve any since their telephone lines could be switched. Two large wooden stations at Fort Hamilton are shown in this 1955 view, protected by an earthen wall seaward. (HM.)

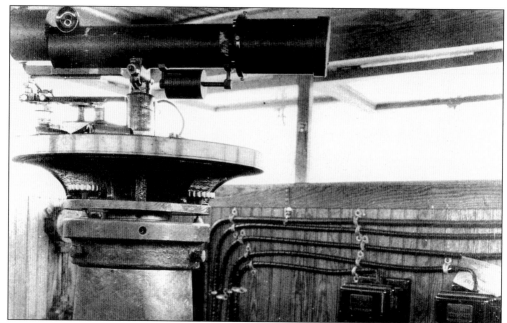

While taken at Fort Tilden in the 1920s, this photograph is a closeup of one of the observing instruments in a typical fire control station. The optical scope is an azimuth instrument, a 15-power telescope revolving on a compass scale, used to determine the angle of sight to a target, or sometimes as an observation telescope for a battery commander. Each of the major posts could have up to a dozen separate stations in use at a time. (NA.)

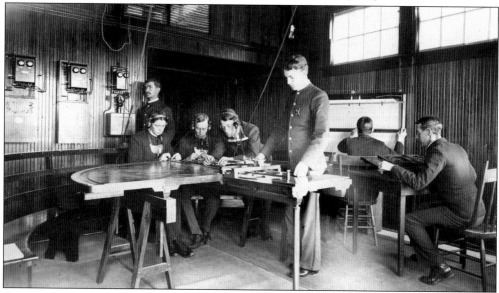

Fire control stations were connected by telephone to specially equipped plotting rooms built either adjacent to the stations or inside the gun batteries. Range information was collected and plotted on a plotting board, the semicircular wooden table in the center, and transmitted to gun crews who set elevation and azimuth. This Hancock photograph, taken in the second decade of the 20th century, shows three men doing the plotting while three others are operating mechanical devices that correct for variables such as tide height and wind direction. (OM.)

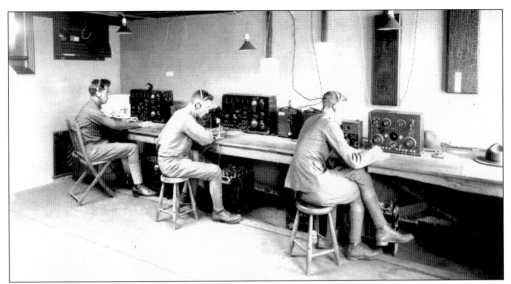

After the guns were removed from Hancock's Battery Potter in 1910, since the gun-lift mechanism had never worked particularly well, the spacious and high roof of the structure became the location of a row of command and fire control positions. This 1919 illustration shows three battery-operated radios inside one of the wooden rooms on the roof in use by soldiers who can radio other forts, mineplanting ships, and target tugs using both Morse code and radiotelephone. (SH.)

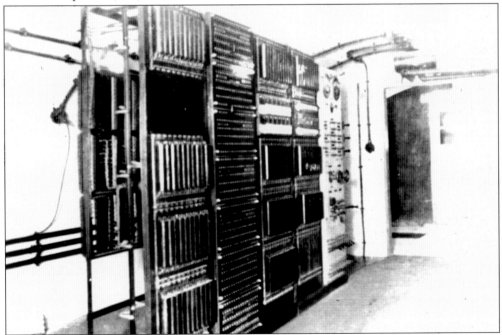

The elaborate system of telephone lines connecting the battery commanders to the gun batteries, fire control, fort and battle command, and other support functions required the use of a fire control switchboard. At times, these were placed in purpose-built, protected buildings, as at Forts Hamilton and Wadsworth, but at Fort Hancock it was found that the old mortar battery from the 1890s would provide adequate space and protection for this function. (SH.)

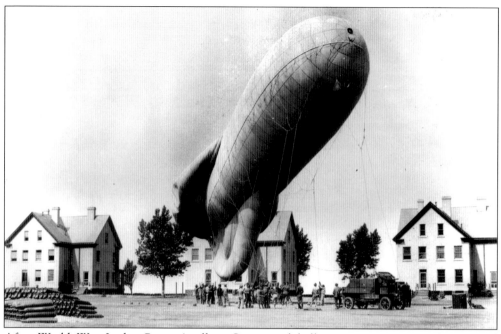

After World War I, the Coast Artillery Corps used balloons to augment its fire control responsibilities. Hangars were built at several posts, balloons distributed, and crews trained. It was a short-lived experiment, and most balloons were withdrawn within a few years, although the hangars were retained for storage. Pictured here in 1919 is one of the hydrogen-inflated Fort Hancock balloons ready to ascend. It is tethered to the winch truck, and gas cylinders used to inflate it are on the left. (SH.)

Another important addition to the defenses in the early 1900s was the installation of searchlights. Most of the large forts received several 60-inch electric searchlights, needed for finding and illuminating nighttime naval targets. Some were emplaced in simple concrete or wooden shelters, while others, such as this one at Fort Hancock in 1936, were placed on towers. This one, with its counterweight on the right and the searchlight's shelter at its top, can be raised from its concealed position. (SH.)

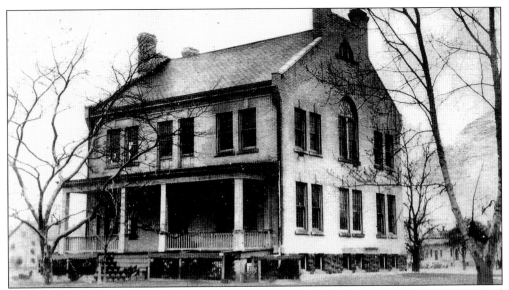

At the same time the harbor defense batteries were being built, the forts acquired, or augmented in the case of long-occupied reservations, various post buildings necessary to maintain an active garrison. All six Endicott posts—Hancock, Wadsworth, Hamilton, Schuyler, Totten, and Slocum—plus Governors Island were well provided with cantonment structures. Each post had an administrative headquarters, such as this handsome brick building at Fort Hancock, seen in the 1890s. (KS.)

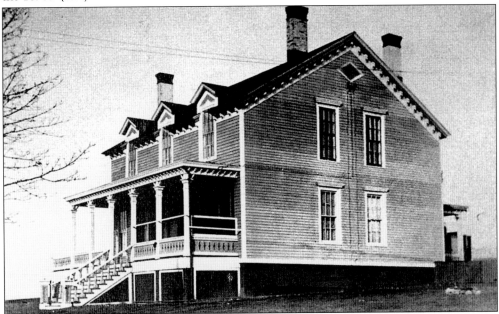

Officers' houses were significant structures, meant to indicate differences between the officers and their troops. Carefully planned to line one side of the post's parade field, often with good views of the water, they were one- or two-family structures. This 1878 house at Fort Schuyler was photographed in 1905. Victorian porches were popular in both private and post construction at the time, and the officer and his family would enjoy sitting out there in the evenings. (NA.)

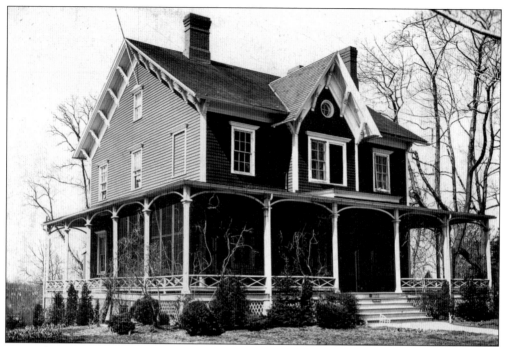

Married noncommissioned officers' quarters also received careful consideration at the harbor posts. The technical aspects of the Coast Artillery Corps demanded a well-skilled contingent of professional soldiers who would remain in the army for many years. Most would get married and would raise children. Retaining them meant housing their families in quarters comparable to houses in civilian life. One of Fort Totten's noncommissioned officers' quarters dates from the 1880s and reflects contemporary architectural design style. (TM.)

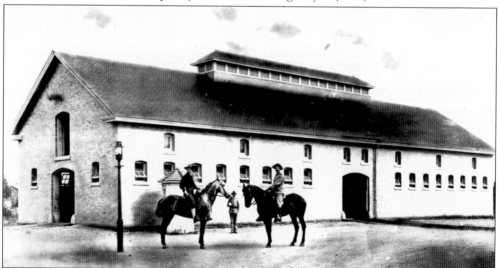

Well into the 1930s, the harbor defense posts continued to board army horses as officers' mounts and to employ mules for pulling wagons. Post stables, and sometimes separate mule barns, were built in the 1800s at the forts, and soldiers learned to be blacksmiths and mule skinners. This brick stable at Fort Hancock, shown around the time of World War I, has a hay loft above the animal stalls. (SH.)

Over time, the army became more conscious of troop morale and began to add recreational facilities to the military posts. These are the Fort Hancock gymnasium and YMCA buildings as they appeared in a postcard from the early 1920s. Wealthy families sometimes provided money for these facilities. Olivia Slocum Sage, for example, donated $50,000 in 1909 to build the YMCA at the island fort named for her uncle, Gen. Henry Warner Slocum. (KS.)

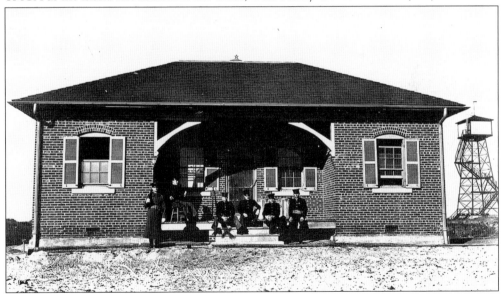

At the other extreme was the need for facilities when garrison troops did not behave well. Any post of significant size had its own guardhouse, its local jail, often located at the post's main gate. This brick Fort Hancock structure was located on the western side of the reservation not far from the Sandy Hook lighthouse. Some of the men going on guard duty are gathering in front. A fire control tower is in the right background. (KS.)

Religious chapels were long a necessary part of the forts' cantonments. As additional troop barracks were constructed at the harbor posts over the course of a century, new chapels replaced smaller ones. Fort Hamilton had five chapel buildings during this period of time, with this 1941 standardized World War II structure replacing those from the 1880s. This chapel building was itself replaced with a brick chapel in the early 1970s. (NA.)

Medical facilities, including clinics for daily sick call and hospitals for the illnesses and injuries of nonmalingerers, were also integral parts of the forts. Each post hospital contained patient wards, an operating room, a pharmacy, a radiology room, a kitchen, and a dining hall. This post hospital at Fort Schuyler at Throgs Neck was typical. The wooden building was constructed in 1883 and cost $13,000. This 1905 photograph shows it still much in use for the garrison. (NA.)

Five

INCREASING THE RANGE

Dramatic increases in the range of naval guns occurred from 1910 to 1915, necessitating a response from Coast Artillery Corps defenders. New classes of enemy ships could easily outrange the American disappearing guns and mortars, potentially neutralizing them without their having a chance to respond. A new review board created in 1915 addressed the need for new weapons and defenses, and New York's harbor benefited from these recommendations. At Fort Hancock, two long-range 12-inch batteries were constructed from 1917 to 1919. At a new reservation near Rockaway Beach, Fort Tilden was constructed. Its primary armament was Battery Harris, two extremely powerful new 16-inch guns on high-angle carriages, which could fire a shell weighing over a ton almost 30 miles out to sea.

Also, during World War I, New York City received its first permanent antiaircraft batteries, placed at the harbor forts and manned by Coast Artillery soldiers. Mobile artillery units, both towed and railway, developed for use by the American Expeditionary Force in France, were made available after the war for use at the harbor forts. However, the cutback in funds and personnel after "the war to end all wars" did affect the harbor's defense. By the mid-1920s, the size of the units and the number of guns armed and manned decreased. No new batteries were built after Fort Tilden's Battery Harris until World War II. Defense of the eastern entrance to Hell Gate was dropped; the forts farther out in the sound off Orient Point would prevent an enemy from entering New York City's harbor by this route.

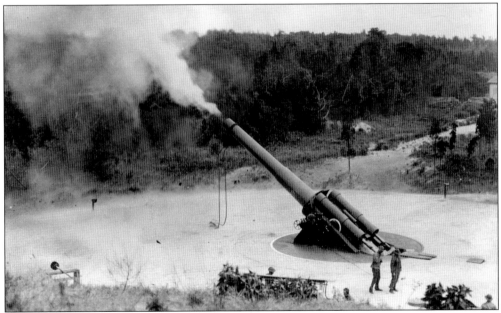

Fort Hancock received the first of the new long-range batteries recommended by the 1915 board. Four 12-inch rifled cannons were emplaced on new high-elevation barbette carriages in two batteries at Fort Hancock. Batteries Kingman and Mills were located side-by-side on a newly cleared site south of the main cantonment. This photograph shows one of the new guns in place and firing in the early 1920s. (SH.)

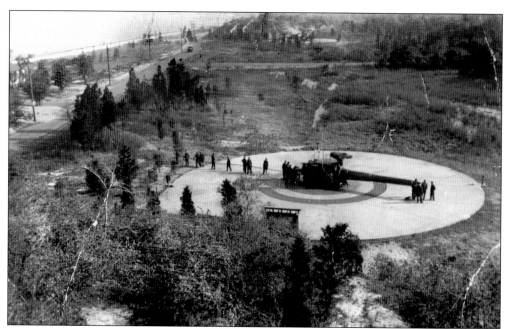

This is a 1940 view of one of the long-range 12-inch guns. This carriage allowed the gun to fire over twice the older disappearing gun's range, to more than 30,000 yards. While the ammunition magazine was well protected, the guns themselves were completely exposed. They were protected only by the distance from their foe and through concealment by camouflage from aerial attack. (SH.)

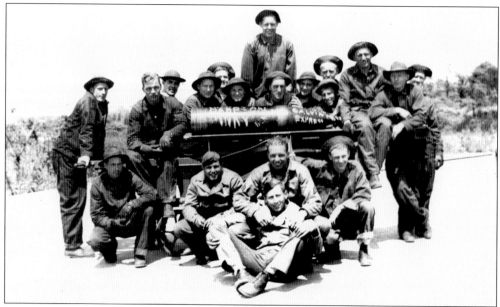

The shells and powder for these guns were rolled out from the magazines on shell carts. In this photograph, men from the 245th Coast Artillery Regiment pose with their graffiti-covered shell at either Battery Kingman or Mills. Similar long-range batteries were added to many of the most important U.S. harbors in the 1917–1921 time period, and most continued to serve as important defensive assets through World War II. (SH.)

During 1941 and 1942, the twin Fort Hancock 12-inch long-range batteries were casemated. This involved building large reinforced-concrete gunhouses or shelters around each of the gun positions. While this gave greatly increased protection from bombs and naval bombardment, the guns' angle of fire was narrowed. This snapshot shows one of the guns with its overhead concrete protection and the new steel shield around the front of the carriage. (SH.)

A soldier and his dog pose on the elevated gun barrel of Battery Kingman or Mills at Fort Hancock. The soldier is also part of the group in the top photograph taken in the 1940s. One of these buddies operated either the manual or the hydraulic elevating mechanism inside the casemate to raise the barrel with his friend and the dog on the end. (SH.)

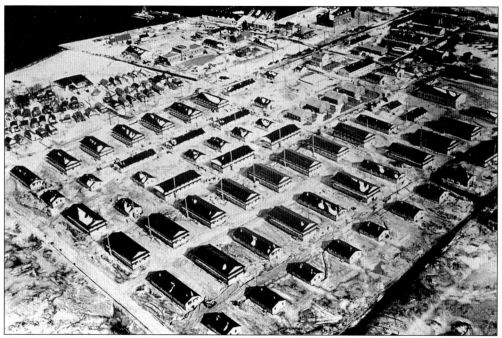

The most significant new addition to New York's harbor defenses in the 1920s was Fort Tilden, located at Rockaway Beach. This site, adjacent to the Rockaway Naval Air Station, was acquired in 1917 and received some relocated 6-inch batteries for the World War I emergency. Soon the fort was developed into a major post with long-range guns and permanent cantonment structures. This 1941 aerial view shows the large number of new World War II barracks and support buildings. (NA.)

Tilden's post hospital is pictured in 1941. Aside from operating the coastal guns, soldiers stationed there walked beach patrols, watching for possible enemy landings. Such an event happened in Amagansett in 1942, when four German saboteurs came ashore from a submarine. Discovered by an unarmed Coast Guardsman who wisely left to raise the alarm, they made their way into New York City. Soon captured, all but one was executed. (NA.)

The major armament of the new fort was its battery of two 16-inch army guns on barbette carriages. Circular platforms for them were built 1,000 yards apart starting in 1921. Completed in 1923, the battery was named Battery Harris for Col. Henry L. Harris. Four widely separated magazines stored ammunition, which was brought to the guns along a standard-gauge rail line. Three separated powerhouses supplied electricity to operate the guns' turntables and elevating mechanisms. (GN.)

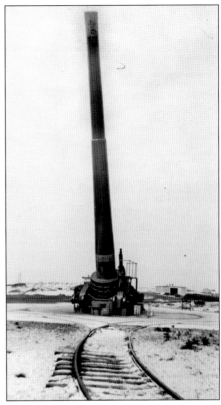

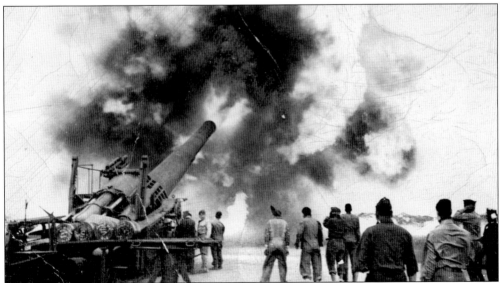

The guns of Battery Harris were the most powerful ever produced for harbor defense service. The 16-inch model 1919 gun could fire a 2,340-pound projectile almost 28 miles. Its barbette carriage turned a full 360 degrees and elevated the rifle to 53 degrees for maximum range. Only two other batteries were built with this gun and carriage, one in Boston and one on Oahu in the Hawaiian Islands. At this 1941 practice firing, some men have wisely covered their ears. (GN.)

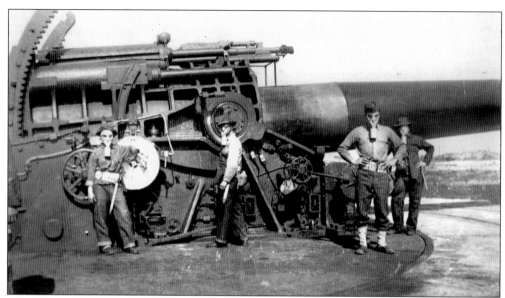

This is a good closeup view of the side of the model 1919 barbette carriage in Battery Harris. The crew is practicing in 1941 while wearing their gas masks. At this time, the most crucial facilities of all active batteries—their plotting rooms, magazines, and latrines—were being gasproofed by building airlocks and installing charcoal filters in their air supplies. Harris was also gasproofed when it was casemated within a few years. (GN.)

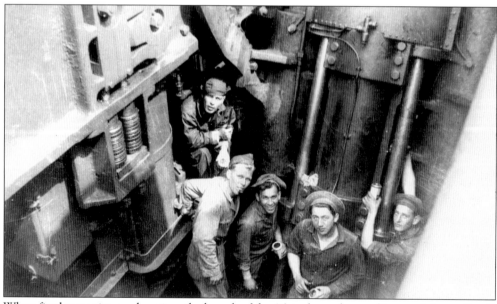

When fired at maximum elevation, the breech of the 16-inch gun lowered into a pit immediately below and behind the gun. Here, men of the 245th Coast Artillery Regiment are cleaning and greasing the mechanisms in this recess at Battery Harris. Weapons of this complexity and size required almost constant cleaning and care, especially with the blowing sand of Fort Tilden. (GN.)

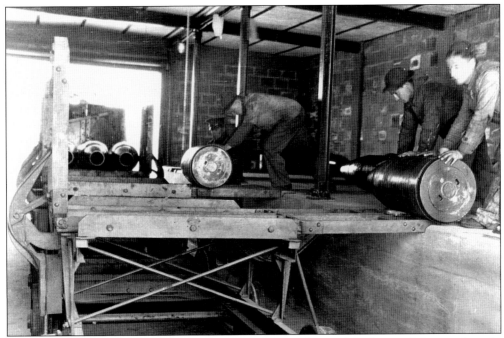

The ammunition for Battery Harris was initially kept in four widely dispersed, but not heavily protected, magazines (essentially just cement-block warehouses). The shells were stored on raised platforms on either side of the railroad tracks that ran through the building. Shells could be rolled directly onto the shell carts from here, as seen in this 1941 photograph. Later in the war, a large bombproof magazine was constructed, and railroad tracks extended to it. (GN.)

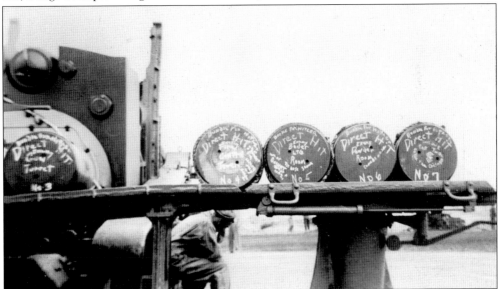

At the gun, the ammunition carts from the magazines were moved to this loading table behind the breech on tracks built into the concrete gun apron. From there, the shells and powder bags were pushed into the breech by a linked-chain hydraulic rammer, similar to those in naval gun turrets. Each of these shells is destined to be a "direct hit" on a particular part of an enemy ship in 1941, although this is a practice. (GN.)

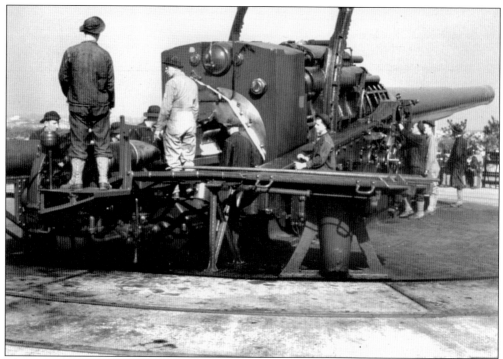

The gun is now depressed to its loading position, and a shell is about to be rammed into the open breech. Powder bags will be pushed in separately after the shell is fully rammed forward to the end of the powder chamber. The breech will next be swung closed and a fuse inserted into it. The gun captain, a sergeant in a khaki uniform, is directing his men in this dangerous procedure. A well-trained crew could fire two rounds a minute. (GN.)

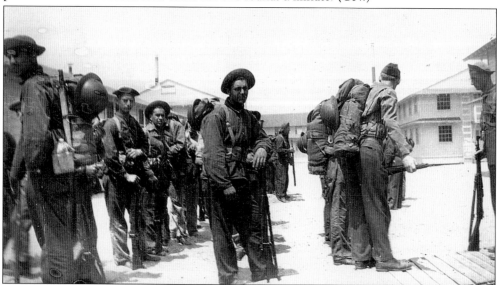

After a forced march across Tilden's desert sands in the summer of 1941, this somewhat tired-looking group of Coast Artillery Corps soldiers stands at ease in the barracks area. The weight of their field packs makes standing straight somewhat difficult. Note the older-style helmet still in use at the time of this photograph. (GN.)

Soldiers' snapshots most often show the lighter side of army life at the harbor forts. These men of the 245th Coast Artillery Regiment at Fort Tilden in 1941 have formed a firing squad for one of their members but have had the decency to blindfold him first. Pointing a rifle, even an unloaded one, at anyone but an enemy was one of the fastest ways of getting seriously chewed out by a sergeant. (GN.)

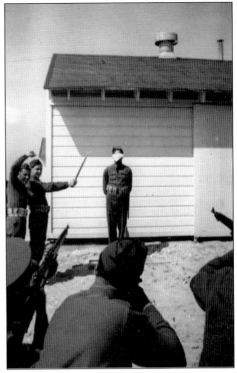

In 1926, Tilden's major armament was the two 16-inch weapons at Harris and two 6-inch pedestal guns each at Batteries East and West, all mounted in the open. To protect them from inclement weather and blowing sand and to allow maintenance in the winter, they were covered with wooden shelters made from old packing crates. The splotches on the gun tube at Harris are primer paint where rust was removed, giving the gun and its shelter an unusual appearance. (NA.)

Like the long-range batteries at Fort Hancock, the big guns at Fort Tilden were given massive overhead protection during World War II. Each of the two gun positions was provided with a reinforced-concrete structure housing the gun and a limited ammunition supply. Construction costing $695,000 was undertaken from October 1941 to January 1943. This picture from an army manual shows one of Harris's gun casemates with its camouflage netting spread out to either side. (NA.)

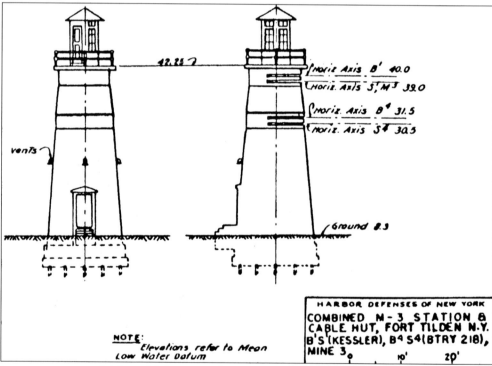

Long-range guns, which could fire into a larger sea area, required additional fire control sites. Based on a system of horizontal baselines, numerous stations along the coast to the left and right of a battery were needed to triangulate an enemy ship's position; Battery Harris had 10. Many were built at small reservations on purchased or leased land. This plan shows of one of Tilden's, placed on the bay side of the fort and disguised to resemble a lighthouse from a distance. Without its lamphouse, it still stands. (NA.)

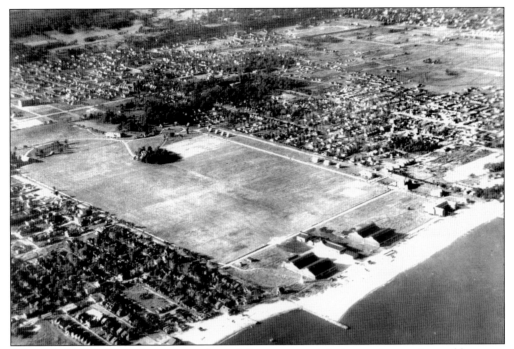

After World War I, airplanes were planned for use as aerial observation stations, able to see ships at a far greater distance than any tower on land. An airfield was needed, and the army purchased property on Staten Island from the Vanderbilt family for Miller Field. This 1935 aerial view shows the land and sea plane hangars near the water's edge. Many of the old estate's fine buildings were retained for housing, a radio station, and garages. (HM.)

In a 1921 photograph, the hangar for Army Air Corps land planes is shown. The field was grass, fine for the slow landing speed of the biplanes of the time. Accurate triangulation from moving planes was a problem, but the pilots could find ships, radio their approximate location, and help aim the guns by watching shell splashes. During World War II, Miller Field was used to park army vehicles before they were loaded aboard ships bound for Europe. (HM.)

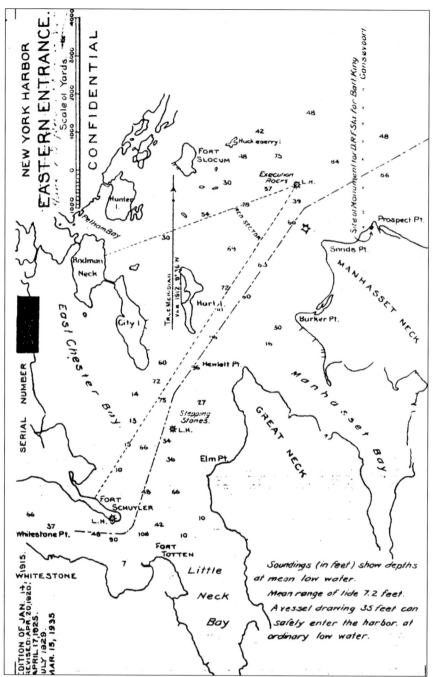

This 1915 map of the eastern entrance to the harbor from Long Island Sound indicates the wise placement of Fort Schuyler, begun in 1833, and Fort Totten, begun in 1862, on either side of the 1,300-yard-wide channel. Sailing ships seeking to pass into the East River to get within range of shelling the city had to navigate around unmarked and unseen shoals and rocks at Execution Rocks and Stepping Stones, sail a good distance directly into the forts' guns, and finally turn to starboard around Fort Schuyler and allow both forts to fire into their broad wooden sides. (NA.)

74

Six

CLOSING THE BACK GATE

The back gate into New York's harbor is through Hell Gate, an appropriate name for the twisting passage, shifting winds, swift currents, and submerged rocks that caused a thousand ships to run aground there in the 1850s. These rocks near Astoria were finally dynamited and dredged by the Army Corps of Engineers by 1886, but the East River entrance to the port was then more accessible to enemy ships, too.

Three fortifications were constructed near the city to effectively close this entrance, and five more were built on islands and points at the eastern entrance to Long Island Sound from the Atlantic Ocean. Of granite first, and then of steel and concrete, Forts Totten and Schuyler near the site of the present Throgs Neck Bridge, and the later Fort Slocum on Davids Island, off New Rochelle, Westchester County, completely barred the harbor to enemies from this direction by making a seaborne attack too costly for them in ships and men.

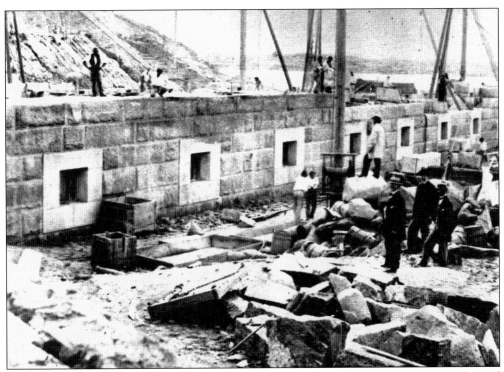

Building a granite fort was a significant undertaking, requiring skills that West Point–educated army engineers possessed almost exclusively. Capt. Robert E. Lee drew the plans for a fort at Willets Point in 1857; construction of the fort is shown here in 1863. Stone was quarried in Maine, brought in on barges, and shaped and finished in this stone yard to fit a particular spot in the wall. The stone was then lifted into place by wooden derricks operated by laborers. (TM.)

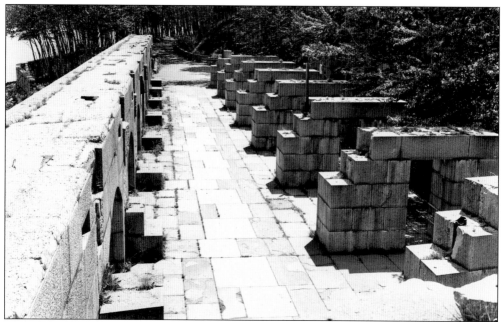

Work on the stone fort ended in 1869 because it had been rendered obsolete by the accurate fire of rifled artillery that could hit the same spot repeatedly. This 1950s photograph shows the second gun tier with its casemate arches incomplete, their bases on the right. Originally, there were to be three more levels above, making it the largest fort in the New York area, but plans were scaled back to two levels and then never finished. (TM.)

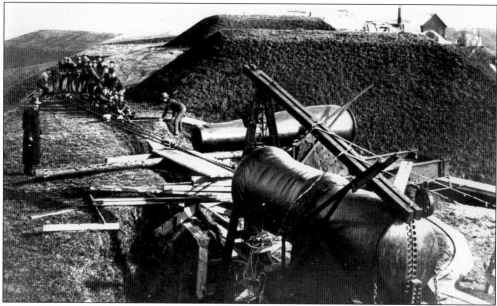

One lesson of the Civil War was that yards of dirt were better protection than several feet of granite, so in the 1870s, seacoast guns such as this 15-inch Rodman at Fort Totten were emplaced behind earthen embankments, firing over them. Weighing 50,000 pounds, they had to be hauled into position on skids moved by block and tackle, with dozens of soldiers straining on the ropes. The hills between the guns covered their powder magazines. (TM.)

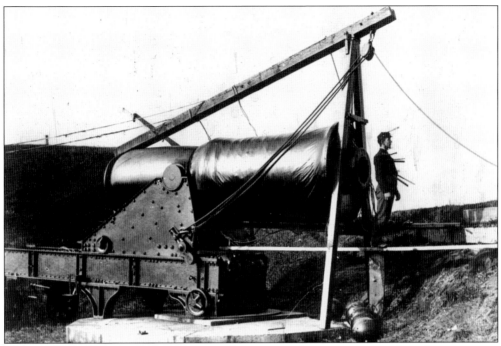

The soldier in this 1892 photograph is not the target at a bizarre execution; he is demonstrating the power of the electromagnet, which this cannon has been turned into by winding coils of wire around its barrel and connecting them to a generator. Metal tools are being held at right angles to his body as part of experiments being conducted at Fort Totten by army engineers studying electricity. Next, the magnet will pick up the five 300-pound cannonballs on the ground. (TM.)

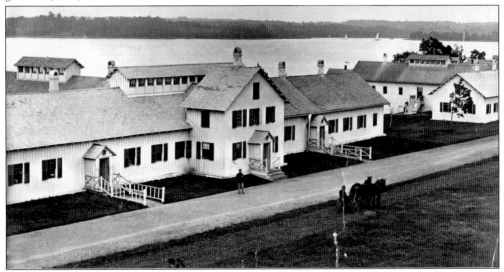

Wooden barracks and mess halls housed the soldiers stationed at Fort Totten for 40 years until brick buildings were constructed in the 1900s by the Quartermaster Corps for Coast Artillery troops manning the new Endicott batteries on the heights above the old fort. One soldier is cutting the well-tended lawn on a mower with the usual motive power of the time. Little Neck Bay is in the background. (TM.)

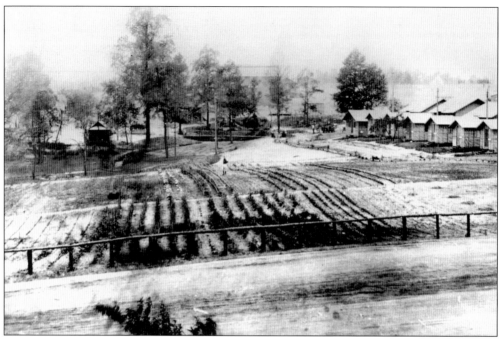

Army life was not always completely military. With low pay for enlisted men, those with families found that some civilian activities were necessary on the posts for them to survive. At Fort Totten in the 1890s, soldiers work their farm on unused land and tend their vegetable patches to provide food for their families or to sell in the Whitestone neighborhood. The housing on the right consists of wooden shacks covered with tar paper. (TM.)

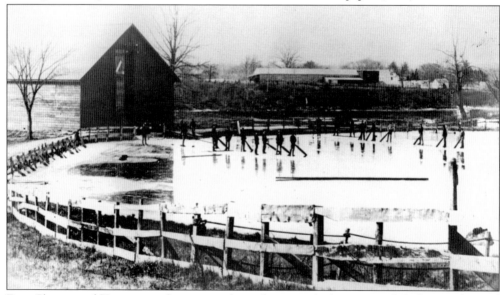

Forts Slocum and Totten were fortunate to have their own freshwater ponds before mechanical refrigeration became available in the early 20th century. These men at Totten in the 1890s are cutting ice in the winter to be stored throughout the summer, allowing food to be preserved. Their long saws cut the ice into blocks, which were stacked in the icehouse, surrounded by insulating sawdust. Other posts had to purchase their ice in the summertime. (TM.)

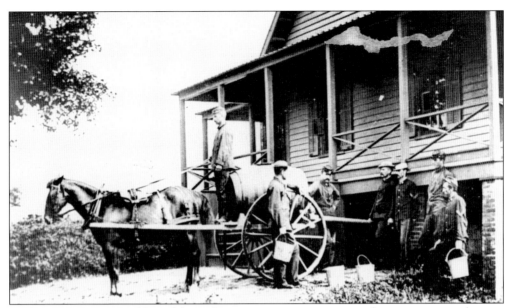

In the 1890s, Totten's soldiers delivered water to quarters on post in this water wagon, drawing water from wells and emptying their buckets into cisterns in the basements. Hand pumps brought it up to sinks in the first-floor kitchens. All of the chores on post, such as stoking the coal furnaces in each building, hauling and burning garbage, and crushing cinders to pave roads, were the duties of the artillery soldiers stationed there. (TM.)

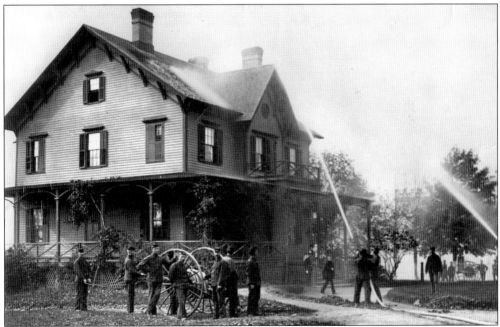

Soldiers also fought post fires, and the lack of water mains greatly hampered their efforts. In 1890, men are spraying water on this officer's house with a pump operated by teams of men pushing on the long handles of a horse-drawn fire engine. Several groups were needed to keep up hose pressure, and as one team soon tired, another was ready as replacements. The hose reels were pulled by men running to the fire. (TM.)

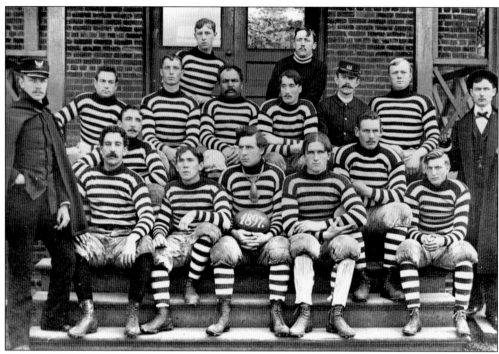

Looking like convicts with guards and the prison warden, these men are Fort Totten's football team in their 1897 striped uniforms. Sports were important for maintaining the morale of troops at forts where there was little military activity and a great deal of time to hurry up and wait. Competitions were set up between companies, and the best men played teams from other forts. Monetary wagers were rumored to have been placed on these heated games. (TM.)

Modeled after a now demolished 1841 turreted stone library at West Point, Fort Totten's wooden castle of 1887 was the post's officers club but earlier held the library of the Corps of Engineers School of Application. Founded in the 1860s, the school taught the practical military skills of bridge building, explosive demolition, fortification construction, and photographic map duplication. This castle still stands and is now the home of the Bayside Historical Society. (TM.)

Fort Totten had plenty of open land in the 1980s for engineers to practice on and in. This rather elaborate bridge, with its logs lashed together by ropes, easily holds the 28 men who built it and would certainly carry loaded wagons, horse-drawn artillery, and maneuvering troops if it were constructed in wartime. Marching men were instructed to break the cadence of their steps to avoid vibrations that might loosen the logs of such bridges. (TM.)

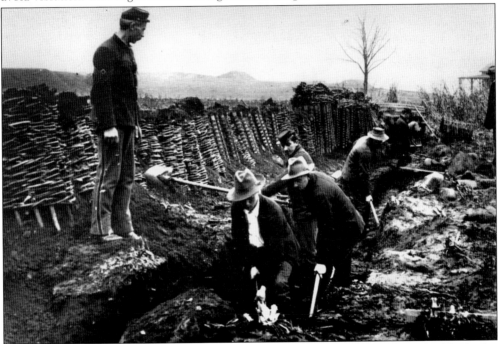

Digging trenches and constructing temporary fortifications in the field was taught, like bridge building, in a practical, though muddier, way at Totten's engineering school. The wooden gabions are filled with tamped earth to protect against artillery and rifle fire, but one still has to dig trenches deeper and deeper, as the instructor sergeant has undoubtedly mentioned several times to his grim-faced students already. (TM.)

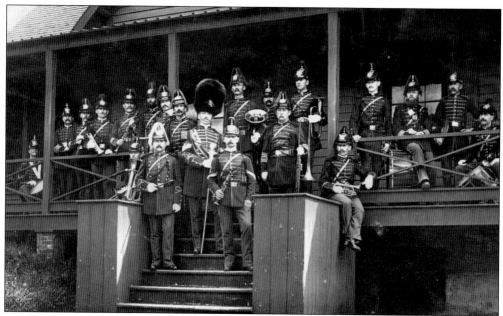

There were post bands at all of the harbor forts, but not for entertainment (although Sunday band concerts were especially popular with post families and local residents, and bandstands were built at all the harbor forts). The bands served a military purpose, because soldiers marched more proudly and smartly to martial music. Fort Totten's 21 bandsmen were photographed in their colorful uniforms on the porch of their barracks in the 1890s. Frequent instruction and practices made them good musicians. (TM.)

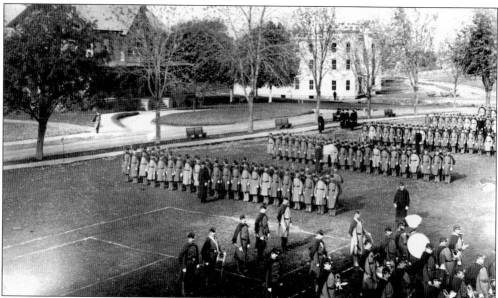

The fort's Coast Artillery Corps companies and the musicians of their band are standing at attention on Totten's parade field one Saturday in 1890. Weekly inspections and parades were the rule, and soldiers who were not all spit and polish risked spending the remainder of the weekend in their barracks cleaning their equipment and the latrines while the others were off on pass. An officer's house and the castle are in the background. (TM.)

After the successes of spar torpedoes in the Civil War, the army and the navy experimented with automotive torpedoes, the army for harbor defense. Fort Totten, on shallow Little Neck Bay, was the site of the Battalion of Engineers' tests of their shore-launched weapons, and these engineer personnel are rowing a measuring ring out into the bay in the 1890s to place it for a torpedo to pass through. The experimental laboratory is in the background. (TM.)

In 1894, one Private Muller is riding on a kitchen chair attached atop a Fisk torpedo. Not meant to become a human sacrifice, this intrepid soldier is steering the unarmed, surface-riding torpedo with the wire in his left hand. Such slow, inaccurate, and easily spotted devices proved to be unusable for harbor defense. Totten's School of Submarine Defense experimented with various underwater explosive devices, developing a practical system of mines used for many years to protect harbors. (NA.)

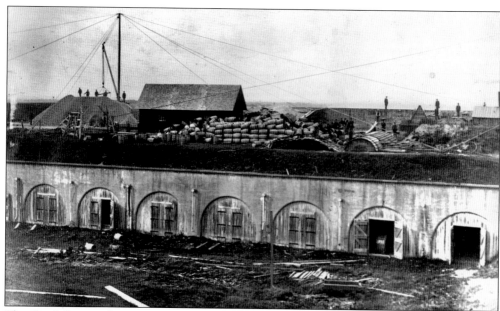

The Confederate submarine *Hunley* reminded the army that an explosion below the waterline could sink an enemy warship. Controlled minefields were soon developed and employed to defend harbors. In 1873, nine 85-foot-long casemates were built at Totten for storing mining materials, and railroad tracks were laid to carry the mines to a wharf for planting across the channel. Mines were connected by wires to observers ashore and were exploded by contact or when electrically fired. (TM.)

These spherical buoyant mines in storage at Totten in the 1890s held 100 pounds of TNT, could be anchored in water as deep as 250 feet, and had a range of more than 100 feet. The iron weight holding one in place against the current weighed 1,000 pounds and a loaded mine over 400. They were placed in the channels only in times of national emergency; the first time was during the Spanish-American War to protect New York harbor. (TM.)

These 1890s soldiers are filling mine casings very carefully. The loading building held only a few hundred pounds of powerful TNT, and the remainder was stored at remote magazines. This building was wooden to limit blast damage to nearby structures should its contents accidentally detonate. Mines were stored empty, and the underwater electrical cables linking them were kept ashore in water-filled tanks to preserve their rubber insulation from drying and cracking. They were electrically tested periodically to ensure their readiness. (TM.)

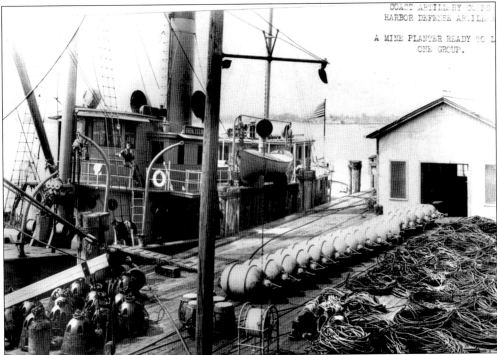

The Coast Artillery's navy consisted of a fleet of some 25 mineplanters, from 165 to 189 feet long, manned by soldiers and stationed at many harbor defenses, including Panama and Manila. The *General Ord* is at the Fort Hancock dock in the 1940s, preparing to lay a mine field in the shipping channels. Anchors on the left, newer mines now holding 200 pounds of TNT, and electrical underwater cables on the right are arranged to be loaded aboard. (SH)

Mines were planted and pulled up periodically for inspection and repair in all weather, and the Coast Artillerymen on the planters' decks followed a strict routine of actions to avoid injuring themselves or damaging the equipment. Viewed from the wheelhouse of the *General Ord*, these soldiers in the 1940s are untangling ropes that will attach a temporary marking buoy before this mine is swung out on the davit and lowered back into the harbor. (SH.)

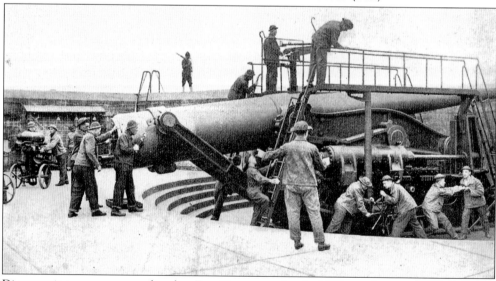

Disappearing guns were emplaced at Fort Totten starting in 1891, sited atop a hill behind the old fort. Battery Mahan, with its two 12-inch guns, was the most powerful, firing a 1,000-pound shell eight miles into the Sound. These soldiers in the 1920s are practicing loading, and a shell cart is ready on the left. Two men are setting the gun's elevation with a handwheel while two others strain to crank the gun down behind the concrete parapet. (TM.)

Mortars were emplaced at Davids Island and at Totten in the 1890s, where an 1880s battery was rebuilt. Davids Island's sixteen and Totten's eight 12-inch mortars fired their shells upward in a shotgun pattern to descend on the enemy warships' decks. This photograph of typical pit construction shows the curved wooden form used when concrete for the arched corridors leading to the other pits was poured. The top will be covered by yards of sand to absorb enemy shells. (TM.)

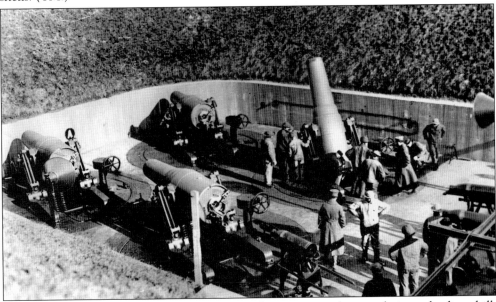

A view into Fort Totten's Battery King shows the mortars and crews during a loading drill. Mortars were lowered so the armor-piercing shells could be slid into their barrels, but the pits were so crowded that each mortar was angled to keep the four 20-foot rammers from interfering with each other. Mortars became obsolete because their range was shorter than that of newer naval guns whose high angle capability could drop shells into their open pits from a safe distance. (TM.)

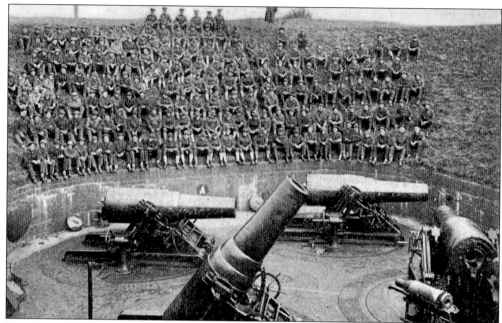

The sloping grass around one of Battery King's two pits creates an amphitheater for 1920s instruction. These mortars were fired into Long Island Sound for target practice, interfering with shipping and yachting occasionally, but Totten's long-range disappearing guns could not be fired because of limited target areas and the nearby windows they might break. The post's troops traveled to Fort H.G. Wright on Fishers Island in summers to fire that post's 10- and 12-inch guns. (KS.)

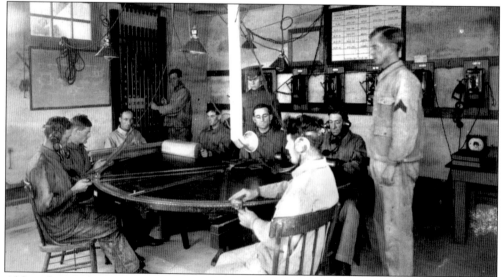

Although not taken at New York's forts, this photograph shows a typical mortar battery plotting room. Before mechanical or electrical analog computers in World War II, Coast Artillerymen located the position of an enemy ship on this semicircular board by triangulation, receiving azimuths from distant observing stations and moving the board's metal arms to correspond. Signal bells told the battery's gunners when to pull the firing lanyards. The speaking tube goes up to the commander's observing station. (SH.)

This 1910 Fort Totten view shows some of the brick barracks with their porches and the post exchange (PX) building. The PX was a store and cafeteria, one of the recreational buildings enabling men to have a reasonably enjoyable off-duty life without going into town, which was expensive and probably rife with bars and prostitutes. Service clubs, gymnasiums, movies, bowling alleys, and libraries were built to fill a soldier's time; many were staffed by YMCA and other volunteers. (TM.)

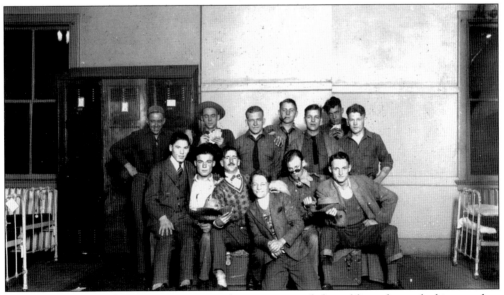

Hamming it up for the camera was a popular pastime, and the soldier who took this snapshot at Totten in 1929 probably sent a copy home to his family to prove that army life with his buddies was not so bad. It was better than the lives of many after the stock market crash and the economic depression of the 1930s. Soldiers were fed, clothed, housed, paid each month, and often trained in useful civilian skills. (TM.)

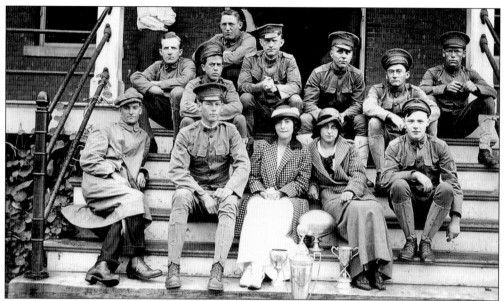

Young soldiers and their friends sit on the steps of a Fort Totten barracks in 1913. Anticipating army needs with war threatening in Europe, artillery training was intensified to prepare men for overseas or harbor defense duty. Soldiers from the forts also went as infantrymen to Galveston, Texas, during the 1916 Mexican Expedition. Soon, guns were taken from the forts to be remounted as field or railway artillery, and many soldiers such as these went into combat. (KS.)

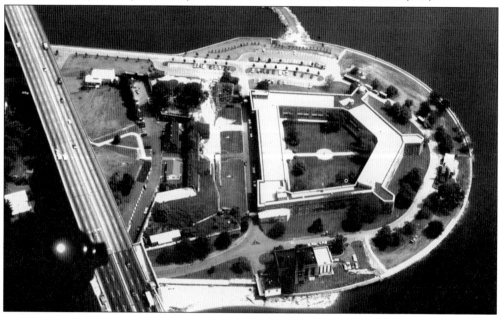

Fort Schuyler, now New York State Maritime College, is seen from the Throgs Neck Bridge. Construction of this three-tiered granite fort began in 1833. Corner bastions protected the walls, and a drawbridge and an earth and granite hornwork to the west kept its land side safe. It mounted 312 smoothbore muzzle-loading cannons, and in the 1890s, two 12-inch, two 10-inch, and four rapid-fire 3- and 5-inch guns were emplaced in concrete batteries, modernizing this fort's armament. (GN.)

McDougall General Hospital was constructed for Civil War wounded on Fort Schuyler's grounds, and 500 Confederate soldiers were also confined inside the fort. Nearby Hart Island in the Sound and Wards and Rikers Islands in the East River also became POW camps, guarded by soldiers from the harbor forts. Artillerymen again garrisoned the post in the 1890s to operate Endicott batteries built then, and brick barracks and other cantonment structures were added to the fort. (NA.)

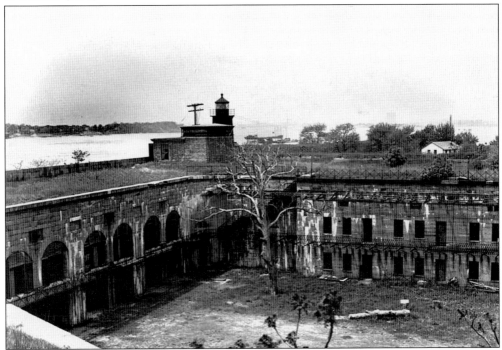

This 1934 photograph of abandoned Fort Schuyler shows a typical interior of an enclosed harbor fort. Gun casemates are built into the thick walls facing enemy ships, and officers' quarters are on the land side. A third level of guns was placed atop; the Throgs Neck lighthouse, removed that year and replaced with a steel tower, and a fire control observation station for the disappearing guns are seen here. The structure was soon extensively renovated for the college. (NA.)

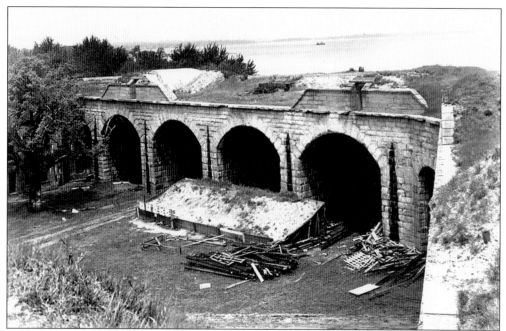

The gun casemates of Schuyler's north side were two stories high with thick wooden floors in the middle, long rotted away before this 1934 photograph. Earth was piled on top for protection, and additional guns were located between the dirt-covered magazines. New York State removed the earthen cover and a built a library in these casemates. The army used the old fort through the early 1930s, and this sand-filled target butt for pistol practice was built in the parade. (NA.)

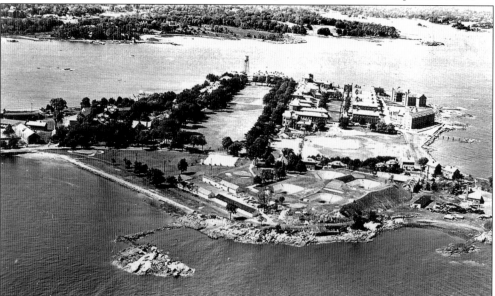

Davids Island, off New Rochelle, was first used by the army in the 1860s for DeCamp General Hospital, which treated 5,000 Union and Confederate soldiers. Through the 1890s, it became a recruiting station. The first seacoast weapons placed at Fort Slocum were sixteen 12-inch mortars, which dropped their shells into the Sound or into nearby bays to prevent landings. In this 1940s photograph, the 4 mortar pits, 10 barracks north of them, and the parade field are seen. (KS.)

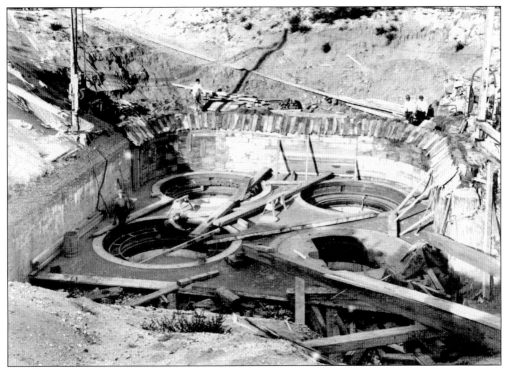

Constructing massive concrete emplacements and installing a mortar and carriage weighing 71 tons was difficult. In one Slocum pit, base rings into which carriages will be placed are being fitted. They must be exactly level, to within a hundredth of an inch, so the weapons will fire accurately. Wooden forms that were used in pouring the concrete walls are in the rear, and slanting boards above them hold back the covering sand. Mortars will be slid in from the right. (NA.)

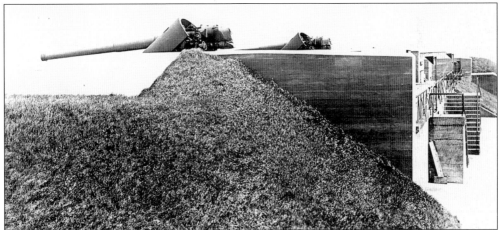

Rapid-fire batteries were built at Slocum to prevent enemy ships from moving behind the island. This postcard shows Battery Kinney for two 6-inch pedestal guns. The adjacent Battery Fraser mounted two 5-inchers. Their guns were removed in 1917, and both concrete emplacements were razed in 1939 for the construction of two brick barracks. This side view shows the protective earth embankment, the battery's two levels with magazines below the guns, and the steel gun shields. (KS.)

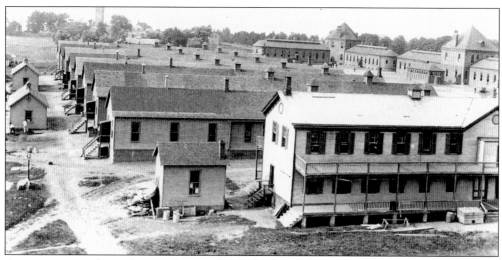

As its mortars and guns became less needed for harbor defense, Fort Slocum primarily became a cantonment for newly recruited troops and for those embarking overseas during the world wars. The island's 119 acres were filled with barracks of varying ages and construction. The brick 1890s buildings to the right were supposed to replace these wooden ones, but all are still being used. With additional barracks built in the early 1900s and 1939, and 80 World War II structures, Slocum housed 9,000 soldiers. (RD.)

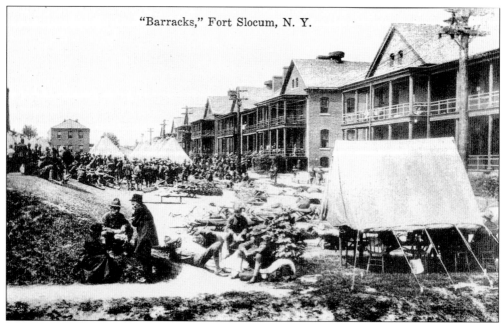

Four permanent barracks line this Slocum street in 1918, but tents were needed for some of the post's soldiers awaiting the voyage "over there." Porches provided access to all rooms on a floor without walking through the dormitories, and they also sheltered windows and doors, permitting them to be open for ventilation in stormy weather. Mess halls were formerly inside but were removed to separate buildings, allowing more beds. (RD.)

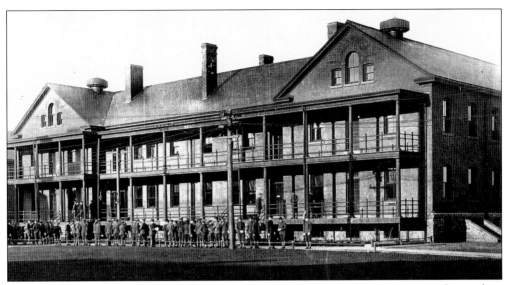

Company barracks were constructed at all forts, following standard Quartermaster Corps plans to house 110 men of one Coast Artillery company, including unmarried sergeants. These men lived, marched, and ate together, building comradeship and unit pride. When manning their assigned gun or mortar battery, these cooperative qualities improved their performance under stress. Milling around after being called from the barracks was sometimes inevitable, but the hurrying and long waiting naturally produced some grumbling. (RD.)

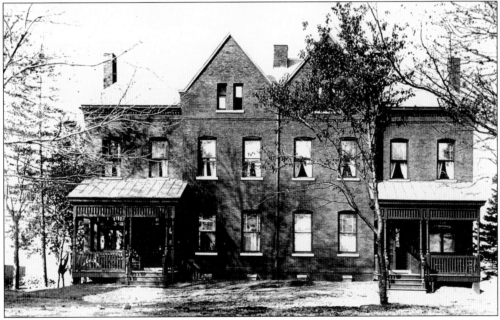

This handsome brick house from the 1890s is one of the double quarters for married majors and colonels that lined one side of the parade field at Slocum, on the opposite side from enlisted men's barracks. All forts had a similar layout because officers, in order to maintain discipline, were not permitted to fraternize with their men. Unmarried officers lived in the bachelor officers' quarters (BOQ), a large apartment house. The commanding officer had, naturally, the finest house on post. (NA.)

The original 1864 wooden chapel on Davids Island was built as part of DeCamp General Hospital. It served the Coast Artillery post for many years until a new stucco chapel replaced it in the 1920s. When the cantonment buildings were filled with soldiers during the world wars, religious services were also held in the much larger drill hall. Officers and soldiers stationed at Fort Slocum were often married in this quaintly nonmilitary structure. (NA.)

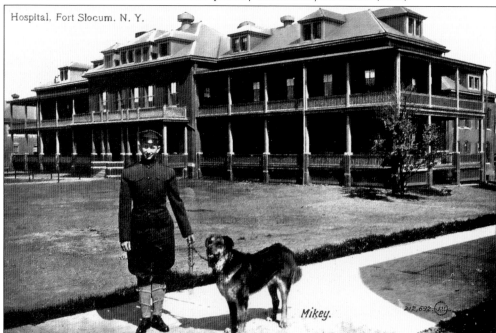

Three hospital buildings were constructed at Slocum, one an isolation hospital used especially for soldiers who had the flu or tuberculosis. This large building is the main post hospital, and the porches surrounding its wards allowed convalescent patients to sit outside. An addition to the rear enlarged its capacity and was necessary with the island's main role as a cantonment site. A World War I soldier is posing on this postcard with his dog Mikey. (RD.)

Seven
FIGHTING WORLD WAR II

In the 1920s and 1930s, the Coast Artillery Corps experienced the same belt-tightening and troop reductions as the rest of the military. The back gate's defenses were discontinued (although the reservations were retained), and at the bay forts, batteries disarmed in World War I were abandoned. However, as war clouds gathered in the late 1930s, planning again turned to harbor defense. Training intensified, existing forts were remanned, and some of the most important batteries improved by casemating their long-range guns. After the war started in December 1941, some searchlights and 3-inch guns were relocated to beaches.

In 1940, construction began for new 16-inch guns at Navesink Highlands and 6-inch protected guns at Navesink, Wadsworth, and Tilden. Numerous new fire control stations were built at strategic points, as were searchlights, anti-motor torpedo boat batteries, and radar detection and fire control facilities. The channels were again mined and this time provided with acoustic hydrophones and magnetic loops, particularly important as the threat from Germany was manifested by submarines rather than surface ships.

As the war progressed, New York became the single largest port for the transshipment of men and material to the European Theater of Operations. The large, relatively well equipped Coast Artillery posts played important parts in the essential logistical chain. All served as induction centers, training facilities, temporary billeting locations, and embarkation centers. In fact, many more soldiers remember these forts as embarkation stations rather than Coast Artillery posts. In 1944, as the likelihood of victory was evident, harbor defense units were substantially reduced in size, and new construction projects were indefinitely delayed.

The first ordeal men entering the army underwent was a complete medical examination. Many were processed at the Army Building on Whitehall Street, but the forts' hospitals also gave these physicals. At Fort Slocum, this benchfull of naked recruits is answering the orderly's routine questions. Next they will meet the army doctors, who will perform their thorough, mass-production examinations. Tags they carry indicate the lockers where they had placed their civilian clothing. (GN.)

Although the army was small and underequipped through the 1930s, soldiers stationed at the harbor's Coast Artillery bases had several weeks of realistic field training each year. At Maryland's Aberdeen Proving Ground, these men from Fort Totten have been awakened at 5:30, probably humming Irving Berlin's World War I song "Oh, How I Hate to Get Up in the Morning" and muttering how they, too, someday are "going to murder the bugler." (TM.)

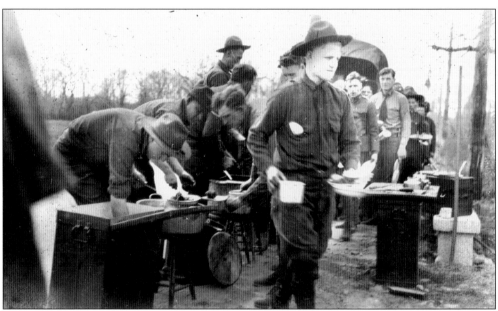

Summer training involved moving the unit and its equipment by truck from New York, and this undertaking itself was valuable experience. The 62nd Coast Artillery antiaircraft battery from Fort Totten has stopped for lunch near Philadelphia on its way to Aberdeen. The cook truck preceded the convoy, and its men have set up their portable kitchen and serving line by the side of the road for these dusty soldiers. (TM.)

After a day of firing their four 3-inch antiaircraft guns at Aberdeen's ranges, these men are enjoying just horsing around with their mascot and smoking while posing for this 1928 snapshot. The wooden barracks was constructed during World War I; its coal furnace is at the left. The metal beds, with springs and cotton-stuffed mattresses, were sometimes bunked one atop the other. For 60 years, many millions of men and women slept on this type of bed. (TM.)

Barracks life was not all fooling around; there were some serious things to be done, including the popular indoor sport of shooting craps. Because men were paid once a month, this game probably took place during the early weeks, when they had still had some cash left. World War II barracks had wider aisles, and the footlockers placed at the end of each bed provided ready tables for playing poker, too. (TM.)

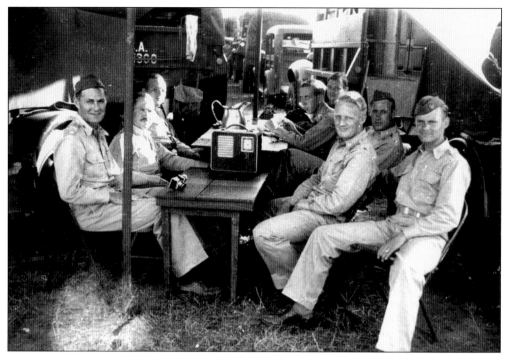

While on 1941 training maneuvers in the Carolinas, these 62nd Coast Artillery officers take a break in their mess tent, chatting, finishing lunch, and listening to a portable radio. Many will soon go overseas with antiaircraft units, remain at one of the harbor defense forts, or become instructors at Camp Davis, North Carolina's antiaircraft school. Units trained there fired their guns over the ocean at targets towed at a distance by Army Air Corps planes. (TM.)

Not all of the 62nd's nights were spent in barracks; field training meant living for weeks in tents and doing laundry in improvised ways. This soldier has strung his clothesline from handy light poles near the flower garden by his six-man tent. At some camps, wooden tent platforms kept the soldiers out of the inevitable mud, but no such luxury was provided at Aberdeen in 1928. Officers' tents, seen in the background, were also without platforms. (TM.)

During the 1930s, the army opened Citizens Military Training Camps (CMTC) at several New York harbor forts to train volunteers in physical fitness and basic military life, preparing them for the war, which some foresaw coming. At Fort Hancock, new men are warmly greeted by two veteran officers. They will spend the summer in tent cities, drilling, attending classes, and exercising. The CMTC program also helped to alleviate unemployment during the depression years. (TM.)

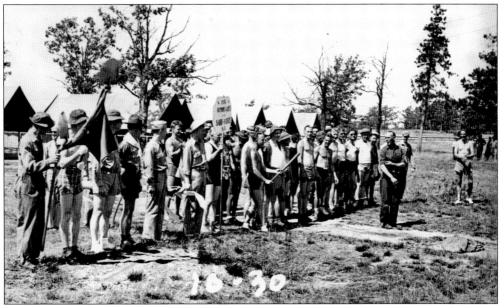

Competitive sports were part of CMTC training, providing fun and exercise while building the cooperative team spirit the men would need when they join a wartime unit. This baseball game, the sign reveals, is part of the "1936 Olympic Games," and the men belong to the "Sand Eaters Athletic Club," an appropriate name for them to choose at Fort Hancock, located at equally well named Sandy Hook. Their tents are behind them. (TM.)

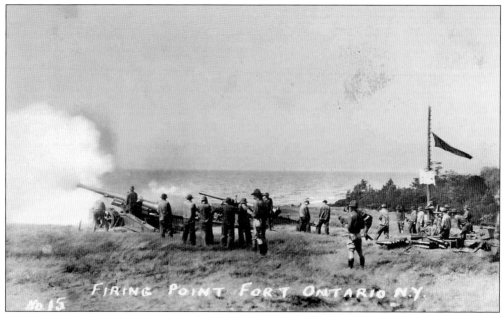

Coast artillery units of the National Guard were also training before the war, and their field exercises included yearly firing of seacoast weapons. Here, in 1938, the 245th is firing four tractor-drawn 155mm guns that sent 96-pound shells 14 miles over Lake Ontario. The red flag aloft warns ships that live firing is now taking place. An officer near the flag observes shell splashes through his telescope, scoring the effectiveness of this practice. (KS.)

The 245th was stationed at Fort Hancock, journeying to northern New York State with their equipment for live firing practices, not possible from the New Jersey shore with busy ship traffic in the lower bay's channels. These men lived in tents for the weeks they were there, but because the post was frequently used by many other units, permanent stone cookhouses were erected where units' field kitchens would be set up, here in 1935. (KS.)

102

Training taught soldiers how to fire and care for their rifles, but the weapons could also be used in humorous snapshots. In 1938, these Fort Hancock men have chosen "long johns" as the uniform of the day, at least until a sergeant happens by. At Fort Totten in 1941, troops in formation by their barracks appear more serious as an officer inspects their rifles for cleanliness. Each released the weapon at the exact moment the officer snapped it out of his grip. Mistiming meant dropping it on the ground or tussling with the officer for the rifle—both sure ways to extra duty. Uniforms and correct posture were also observed in these weekly inspections, and a two-day pass awaited success. (SH, TM.)

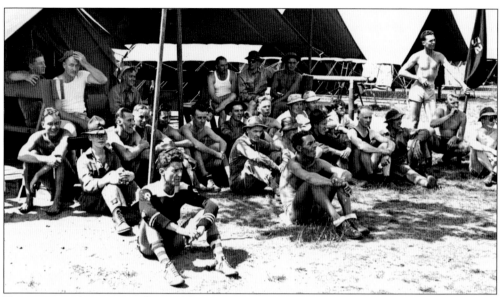

Two groups of Coast Artillery soldiers at Fort Totten in the 1930s are learning about the operation of their antiaircraft weapons and various tactics for their use in differing ways, but the lecture above is no less important for their country's future than the loading and aiming drill on the 3-inch gun below. Totten was too close to the city for this gun to be fired, even using sand-filled inert shells, but aiming it on a target plane from Mitchel Field in Mineola let these men practice reading the azimuth and elevation dials on each side and moving the gun to follow the aiming data shown on them. Little could they realize then that most of them would soon be firing live ammunition at very serious enemies. (TM.)

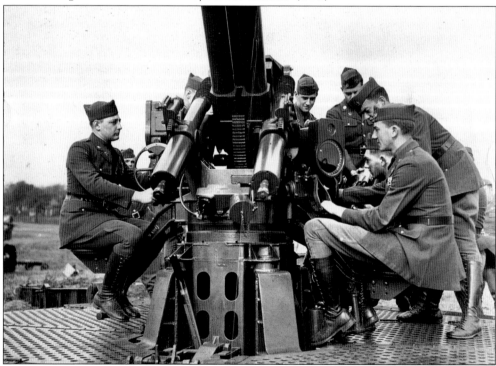

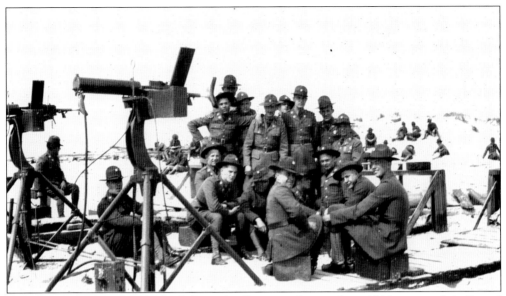

Antiaircraft defense of the harbor's Coast Artillery posts began after a 1916 army study indicated the need to counter this new airborne threat. At the start, 3-inch fixed and mobile AA guns were allocated, followed in the interwar years by the use of antiaircraft machine guns. This 1928 photograph shows two water-cooled machine guns on portable AA mounts at Fort Tilden being manned by the Totten's 62nd Coast Artillery Regiment during a live firing exercise. (TM.)

One of the major reasons the Coast Artillery Corps was charged with being the army's main antiaircraft artillery force was its familiarity with tracking and shooting at moving targets. Optical height finders, able to predict where antiaircraft shells should be aimed to meet a fast-flying airplane, were developed. This 1928 photograph taken during the 62nd Regiment's training shows one of the biplanes at Fort Tilden used to tow aerial targets for the antiaircraft gunners. (TM.)

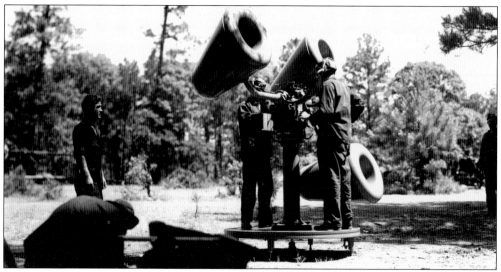

Aside from ground observation, the only aircraft-detection method used by early antiaircraft units was sound locators. These were binaural listening devices that could identify the direction and height of approaching aircraft at a distance before they could be visually sighted. The height operator listened through tubes from the two vertical ears, and the azimuth man listened at the top ears. While World War II radar made this device obsolete, in the prewar years, it was practiced with extensively. (TM.)

Even as war approached, normal life went on at the army forts in New York's harbor. Here an officer and his new wife are leaving the Fort Totten chapel in the 1930s after their marriage ceremony. Riding in the horse cart to their quarters must have been a tradition there, as was that of the bride and groom walking under the raised swords of fellow officers outside the chapel at all military posts. (TM.)

Radar began appearing on the harbor defense reservations during 1942 and steadily assumed a greater role in aiming guns and detecting ships and aircraft. Different types of radar sets were used for aircraft warning, for seacoast gun fire direction, and for general ship surveillance. This Fort Hancock photograph shows the old observation balloon hangar now being used to shelter equipment for the Westinghouse-built SCR-270 sets for aircraft detection assembled and tested there. (SH.)

A Western Electric SCR-268 antenna is erected for testing at Hancock in the early 1940s. Its bedspring-like antenna and three radar scopes mounted on the base of the wartime sets were accurate for surveillance, but not for gun aiming, although it was the predecessor to later successful types. Hancock was important for radar development, as it was close to the Signal Corps' Fort Monmouth and had friendly shipping at the harbor's entrance for targets, unaware of the secret developments nearby. (SH.)

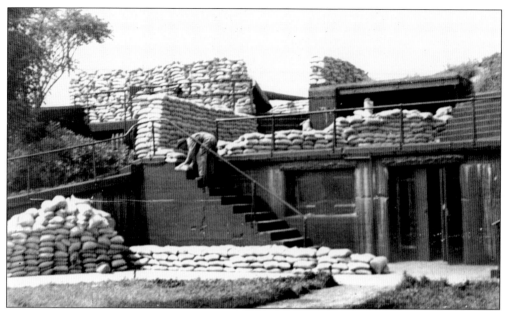

After the outbreak of war, the existing coast defense batteries were again actively manned and readied for action. Wartime conditions involved better camouflage, adjustments to instruments and equipment, and sometimes enhanced battery protection. At Fort Hancock's Battery Peck in 1942, mounting two 6-inch pedestal guns, sandbags were emplaced at its rear to shield men and equipment from the shrapnel and concussion of near-misses. There was plenty of sand nearby to fill them. (SH.)

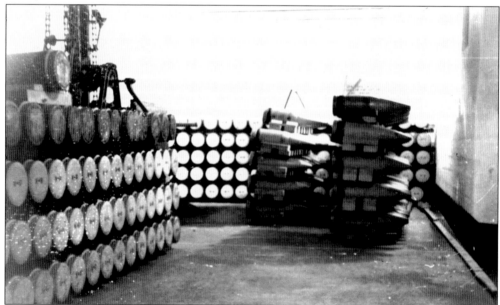

Preparing ammunition, some of which had remained in the batteries' magazines for up to 50 years, was also a part of war readiness. Probably at Battery Peck, these 6-inch shells stored on wooden dunnage are arranged in one of its two magazines and spaced so that they can be periodically examined for cleanliness or damage. Part of the shell lift to raise them to the gun platform can be seen in the upper left behind the closest stack of shells. (SH.)

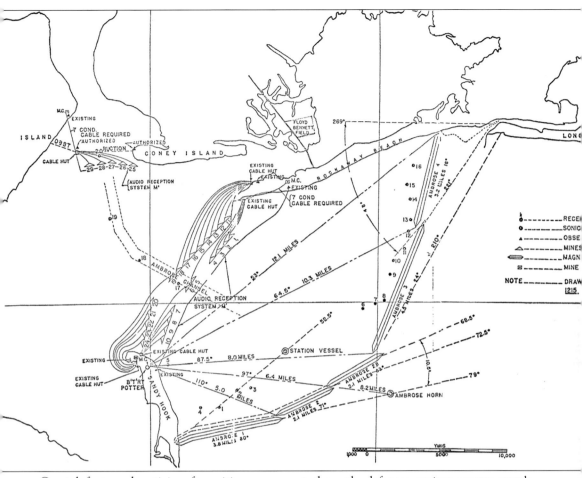

Coastal forts and antiaircraft positions were not the only defenses against enemy attack. Underwater systems both protected the channels through the use of controlled submersible mines and alerted the forts of approaching ships and submarines, a real possibility with German U-boats ranging the Atlantic. Underwater microphones, sonic buoys, magnetic anomaly loops to detect the metal of a passing hull, and antisubmarine nets all gave warning. This 1944 plan shows the lines of mines, listening phones, and magnetic loop placements, all connected to shore observation stations. (NA.)

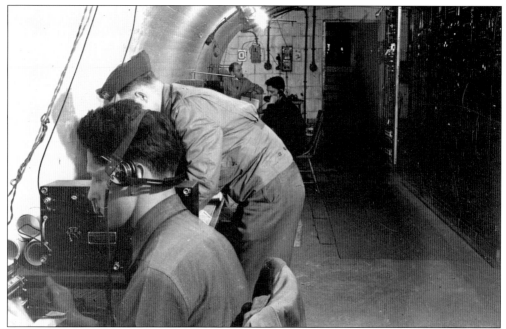

World War II defense coordination was achieved through the operation of a Harbor Defense Command Post. This was a joint army-navy facility that monitored and directed the control of the area's various defensive weapons. For New York's harbor, this command post was located in the secure tunnels and magazines of old Battery McCook-Reynolds, the original 1890s mortar battery near the lighthouse at Fort Hancock. This photograph shows soldiers at work in the message center during the war. (SH.)

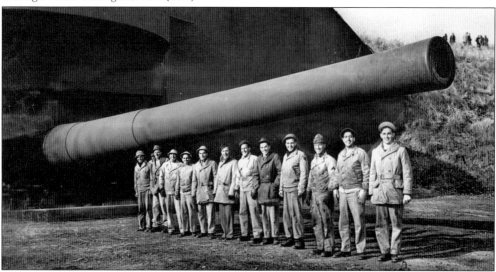

New batteries augmented emplacements already present. The largest was for another pair of 16-inch guns. Battery Lewis at Navesink Highlands, just south of Fort Hancock on the mainland, carried two former navy 16-inch guns on barbette carriages similar to those at Tilden's Battery Harris. Construction began in June 1942 and lasted nearly until the war's end. When completed, it had two casemated gun rooms with magazines and a shared power room located off the protected corridor between them. (SH.)

110

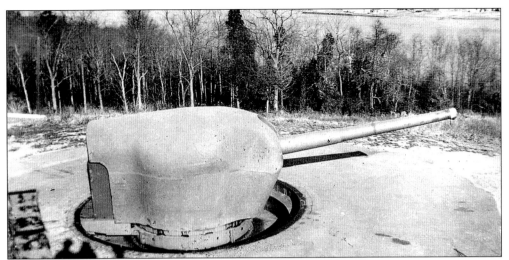

Smaller modern batteries for 6-inch guns were also built. This is Battery No. 219 at Navesink, mounting two 6-inch guns in 4-inch-thick cast-steel shields. Battery naming was suspended during the war, and many were completed without ever being named for a deceased officer. Similar batteries were built at Fort Tilden and Fort Wadsworth, although the latter was never armed. New 90mm rapid-fire batteries were added after 1943 to provide anti-motor torpedo boat protection for the harbor as well. (SH.)

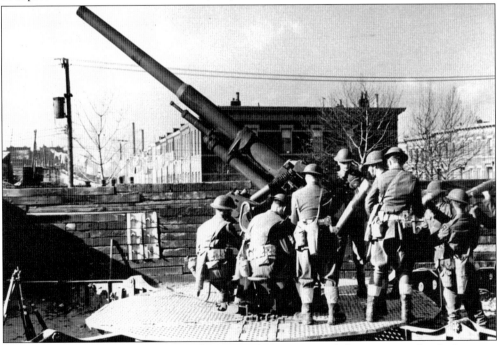

During the early stages of the war, there was also a perceived, but never realized, threat to New York from aerial bombardment. Antiaircraft batteries were manned and progressively modernized through 1944. Some of the AA units were moved from the harbor posts to other potentially threatened locations. This photograph shows the 1942 deployment of the four 3-inch guns of the 62nd Coast Artillery AA Regiment from Fort Totten to Greenpoint, Brooklyn. (TM.)

Another view of the 62nd Coast Artillery in Greenpoint shows the unit's tent encampment and some neighborhood laundry hanging from nearby tenements. Wooden sidewalks were laid in front of the tents to lessen mud when it rained, but life in the field for these troops was not as comfortable as it was for their neighbors. Tanks for oil and illuminating gas storage that the guns were protecting are in the background. The battery was withdrawn in a year. (TM.)

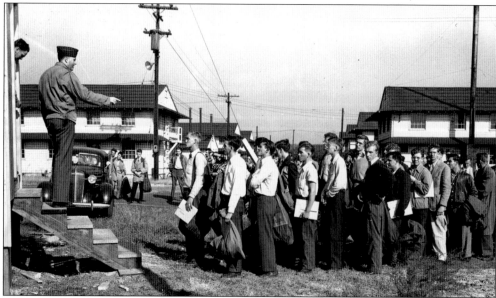

During World War II, forts that defended the harbor were ideally located to help defend the entire country; they became reception centers for new soldiers and embarkation depots for those who had finished training and were shipping out. The many permanent barracks built at them over the years were supplemented by thousands of standardized wooden cantonment buildings. At Hancock, recruits lined up outside a processing building on their first day in the army are meeting one of many who will order them around. (SH.)

A new soldier's first days away from home were always stressful and full of surprises, one of which was the post barbershop, where, no matter how you said you wanted your hair styled, it always came out a fuzzy crew cut. At Fort Hamilton in 1942, these men are receiving the standard military haircut, meant to prevent lice and to instill discipline in new men who may still feel they are civilians. One soldier is from a British Commonwealth country. (HM.)

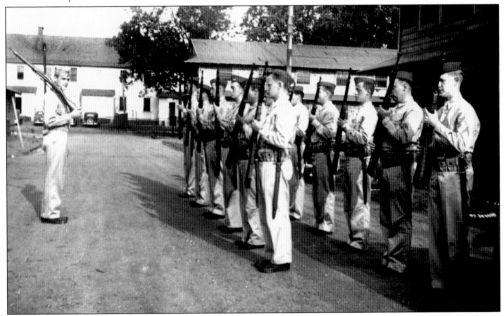

There are three ways of doing things in basic training: the right way, the wrong way, and the army way. This novice squad at Hancock is learning to do the manual of arms in the only way that counts. The soldier drilling them and the private first class on the right have the only uniforms that fit properly. Recruits were usually told by the supply sergeants that they would grow into ill-fitting uniforms, whether it was likely or not. (SH.)

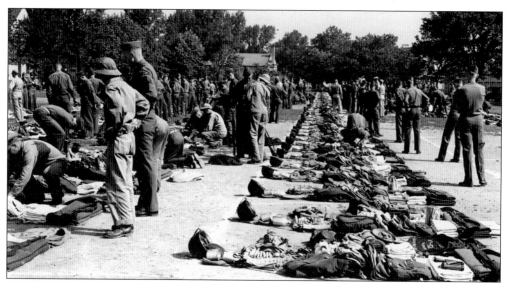

A soldier's need to conform to army life is also evident in this 1940s photograph of a full field inspection at Fort Hancock for soldiers who have finished basic training and are due to be embarked overseas soon. All of their military gear, including a rifle, is spread out in a uniform way for an officer to inspect for cleanliness and completeness. They will not need their civilian clothing for a while. (SH.)

This photograph shows four soldiers in fatigues and the company's first sergeant in his Class A uniform relaxing at Fort Hancock. The wall lockers next to the window hold hanging clothing, while folded items and a toilet kit are kept in footlockers. Laundry bags hang under the window. Weekly white glove inspections by the company commander and sergeants living in rooms near the squad room ensured that barracks were kept orderly and lights out was observed. (SH.)

PX cafeterias, where service men and women and civilians working on the base could purchase meals and snacks, were very popular. Soldiers who were not busy in training, or in training others, could purchase chow different from what the mess halls were serving. These exchanges also contained stores where soldiers and their families could buy food and other household goods at reduced prices, a huge help when living on an enlisted man's pay. (TM.)

Service clubs were wonderful places for soldiers to have available to them when they were off duty in the evenings or when they could not get a pass into town on weekends. A library, bowling alley, writing materials, piano, coin telephones, comfortable chairs, and the good company of their friends drew personnel to these large, sociable buildings. The clubs were constructed within walking distance of the barracks at all harbor forts. This photograph was taken at Fort Hamilton in 1942. (HM.)

Many local women, often the wives or sweethearts of men serving overseas, volunteered as hostesses at the harbor forts' recreational facilities to bring a day of femininity into the lives of men who could otherwise now only dream or remember. This lady is spending part of her Christmastime with these men in a dayroom at Fort Hancock. She may also have brought the dog in the soldier's lap. (SH.)

Soldiers from Allied countries trained at the forts and went overseas from them. At Hamilton in 1942, GIs and men from the Queens Own Cameron Highlanders of Canada are enjoying beer and cigarettes at a service club's bar, and it looks as if the Canadians have just bought a round. Earlier, their kilted pipers accompanied Highland regiments into battle when they attacked. World War I Germans called them "ladies from hell," and not just because of the bagpipe's sounds. (HM.)

Al Capp's popular "Li'l Abner" comic strip brought Sadie Hawkins Day dances to the forts' service clubs. This day in November, women could invite men on dates, the opposite of how things were normally done in the 1940s. The Yokum family home forms the rustic backdrop, and each of the Daisy Maes here, mostly girls from the Sandy Hook area, is contributing to the war effort by boosting morale and giving these men something more of home to fight for. (SH)

If these members of the Women's Army Auxiliary Corps look a little too masculine, they certainly are not typical of the females who joined this noncombat military branch. The stage of Fort Hamilton's service club is the site of this skit, and one can imagine several things that this WAAC first sergeant has just been yelling at his uncomfortable troops. The audience, men and women, would have loved it all. (HM.)

Two million women volunteered for the U.S. Army, U.S. Navy, Marine Corps, and Coast Guard, releasing men for combat and filling positions for which they were well qualified. Many became nurses serving in field hospitals, hospital ships, and stateside facilities. Four hundred of these officers were killed, some as prisoners. Recruits are being sworn in at Hancock and will work in places such as radio and cryptographic stations, offices, and training schools. Many women also flew new planes from aircraft factories. (SH.)

In 1943, the word "Auxiliary" was fittingly dropped from the name of their branch, as women had proven themselves to be an integral part of the army, not just adjuncts, as the original name implied. These WACs stationed at Fort Hamilton are celebrating by painting out that offensive "A" on their barracks. Uniforms were military but were meant to be attractive. They were styled by Seventh Avenue designers working with WACs of the Quartermaster Corps. (HM.)

This scene must have happened a million times. His helmet and a soft cloth provide a safe bed for five kittens, and mamma seems to approve. The cooks at his Hancock mess hall kitchen will supply warm milk, and other barracks will happily adopt the kittens as mascots. Helmets filled a number of such needs unimagined by their designers. Washing in them was fine, but cooking in a helmet might take away the hardening temper of its steel. (SH.)

Mail from home was a great morale booster, and the army devised the V-mail system to speed tens of millions of letters moving both ways overseas each month. A letter was written on special paper that was folded as an envelope. Instead of this paper crossing the ocean, it was microfilmed, and reels containing thousands of 16mm negatives were flown across. Letters were then reproduced and sent on to the recipients. These Hamilton mail clerks are sorting letters and packages in 1942. (HM.)

Hollywood movie stars entertained troops at the forts and traveled overseas to combat areas, bringing some home, humor, and lovely women to the fronts. Glamorous Lana Turner is signing this 12-inch shell on a loading truck at a Fort Hancock battery as four lucky soldiers watch. A show by the troop of entertainers touring with her will follow, held outdoors or in the largest available building to permit thousands of GIs to watch. (SH.)

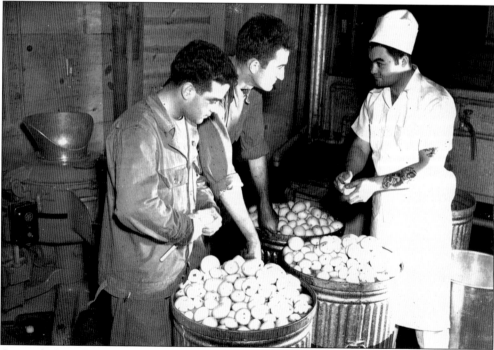

Certainly less glamorous was kitchen police duty. Daylong KP involved cleaning the chow halls, scrubbing pots and pans, carrying stove coal, and helping to prepare and serve food. This tattooed cook at Hamilton has been in since at least 1935, and at Panama in 1939. No one ever joined the army for its food, but everyone thrived on it while making up derogatory names. "Something on a shingle" and "hockey pucks" were most frequently heard. (HM.)

A winter wonderland Hancock may seem here, but all of that white stuff has to be removed from roads, especially in front of officers' homes. With thousands of men there at one time, most waiting to travel to the Brooklyn Army Terminal to board ships, crews of soldiers were used instead of snowplows to clear roads. This was a make-work job, but it kept men who were idle from becoming restless and out of shape. (SH.)

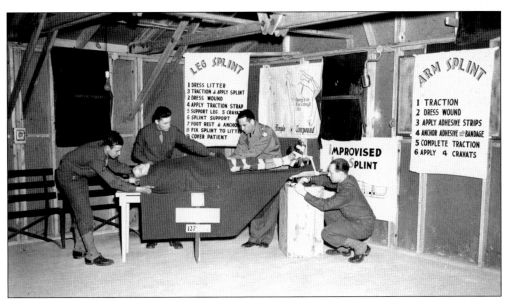

Soldiers were also busy in realistic instruction, where they were taught skills certain to be needed. At Hancock, men are practicing first aid on one of their resting buddies. Early in the war, infantrymen wore World War I puttees over shoes and pants legs, but combat boots with leather tops happily replaced them. Instruction often used acronyms to help soldiers remember what steps to follow. BASS (breathe, aim, slack, squeeze) was the way to fire a rifle accurately. (SH.)

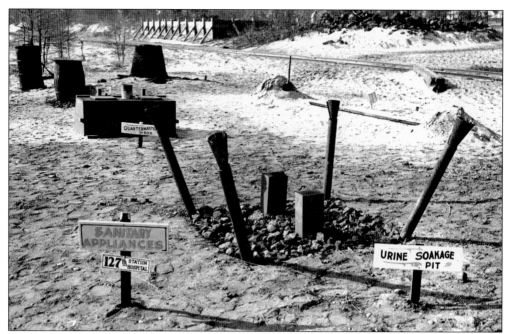

When creative GI minds alter army terminology into names with a practical relation to their own lives, the "urine soakage pit" and "quartermaster box" at Fort Hancock turn into, well, far shorter and more descriptive terms. Field sanitation was an important subject, however, as illness reduced the effective strength of a unit. Tubular metal shipping casings that held 155mm artillery rounds were more often available in combat areas than pipe and funnels. (SH.)

The construction program begun before the war resulted in large villages of barracks and other cantonment buildings added at the coastal forts. Among 50 standardized types were chapels, such as Fort Hamilton's, where Catholic mass is being celebrated. Chaplains of all faiths joined the army as officers and were sent to all posts and overseas areas to bring hope, meaning, and solace to soldiers. (HM.)

A cold 1941 December finds soldiers on guard duty near their squad tents at Hancock, used because barracks were not completed. These "tin pot" helmets are World War I leftovers. The soldier aiming at his friend taking this snapshot is only fooling just now. Men on guard were quizzed on their rote-learned general orders by the officer of the day. A soldier who forgot one would be forced to march around for hours loudly chanting the 10 instructions. (SH.)

In their dayroom at Fort Hamilton, soldiers field strip and clean their .30-caliber M-1 rifles. The men had to take apart and reassemble the weapon at night—good practice should it jam on a battlefield. Soldiers practiced this skill sitting under blankets in the barracks so they could not see their hands. Friends would sometimes slip extra parts from other rifles in front of them and laugh at their consternation at having something left over. (HM.)

After months of training, bonding with new friends, and adjusting to army life, the day always came when orders arrived and the unit shipped out. These soldiers are lined up behind their barracks at Fort Hamilton, listening for their names to be called out. Their next assignment will be a harbor defense fort, an advanced school, or combat. All of their possessions are packed into duffel and laundry bags. The soldiers not being transferred look on placidly. (HM.)

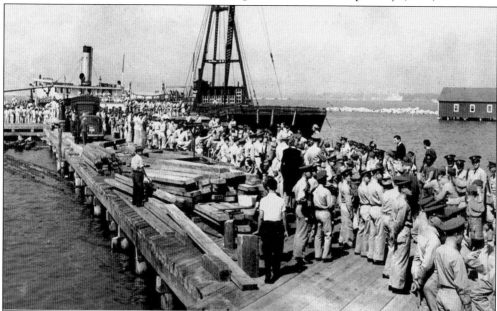

Soldiers with their rifles are waiting at Totten to board the army vessel *Ordnance*, a 120-foot steamer that plied the harbor bringing men and supplies to coastal forts. Its next stop from here, although, will be an embarkation pier in Brooklyn, Manhattan, or New Jersey. Without these forts, used for training and mustering as well as harbor defense, troop movements from the New York area would have been limited as men would have to be quartered farther away. (TM.)

Eight
ENDING WITH MISSILES

At the end of World War II, it was obvious to the army that long-range guns emplaced along a coastline could not prevent an enemy from landing nor keep a determined foe from destroying any harbor. Bombers over Germany and Allied landings on the defended Normandy coast in 1944 showed that all cities, harbors, and fortifications were vulnerable to air attack and that invasions did not require the capture of a port to be successful. Thus, the Coast Artillery became the Antiaircraft Artillery branch, a role that many Coast Artillerymen had already been performing throughout the war in Europe and the Pacific.

What did continue in the 1950s was the use of several harbor forts to defend the New York area once again, but now with Nike missiles. Ideally located for batteries of these longer range antiaircraft weapons, underground emplacements were constructed at Forts Hancock, Tilden, and Slocum, and the Navesink Highlands became the Highlands Air Force Station, an area control and command site. Its ring of 19 Nike firing batteries and five control and administrative sites made New York still the most heavily defended harbor in the nation.

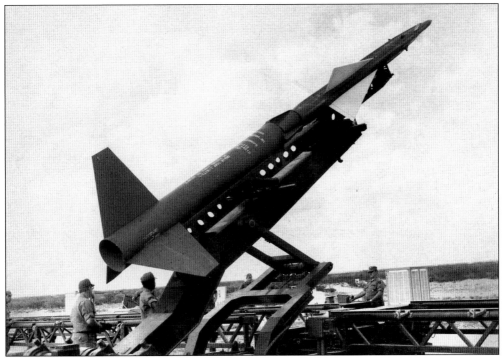

Named for the Greek goddess of victory, the Nike system used the first successful surface-to-air guided missile. Emplacements were constructed in the New York and New Jersey area for batteries that could each launch up to 32 missiles. A Nike Ajax, the earliest type, is being raised by its elevated launcher at Fort Hancock. Its range was 25 miles, but later Nike Hercules missiles would travel 85 miles and could be fitted with atomic warheads. (SH.)

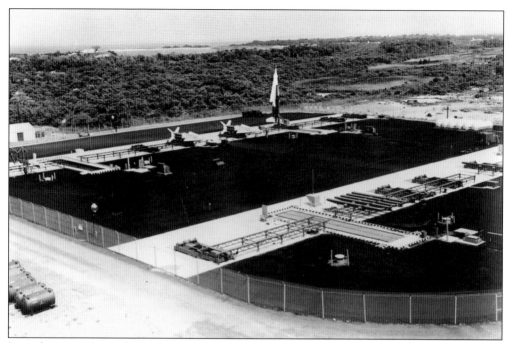

Launching areas were located at least 3,000 feet from their control sites and contained either two or four large underground rooms where eight missiles apiece were stored. These were raised, one at a time, on 30-foot elevators and slid along rails onto launchers that raised them upward 85 degrees for firing. Hancock's launch area in 1959 shows the reinforced-concrete tops of the pits, the closed doors of the long elevators, rails and launchers, and three missiles. (HM.)

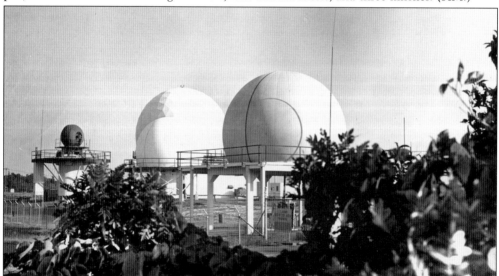

Acquisition, missile tracking, and target tracking radars—two of them inside inflated domes—sit at Hancock's fire control area. They were usually located higher to increase radar range, but Sandy Hook offered only a flat area. This part of the base also contained the launching computers, quarters, recreation and mess halls, and the battery's administrative offices. Soldiers spent their days carefully maintaining the missiles, especially the dangerous, liquid-fueled second stage. Practice firing was always done at a western firing range. (SH.)

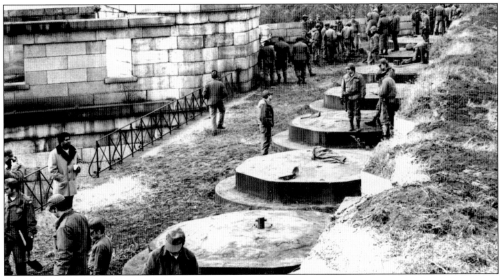

Most of the harbor forts are now parks; only Fort Hamilton is still an active army base, but open to visitors. Maintaining granite forts is difficult, as settling, rain, seawater, and vegetation cause cracking and weakening of their barrel-vaulted casemates. In 1970, these National Guard soldiers from the 101st Cavalry are at Battery Weed to clear weeds and trees from the parapet level. The center pintles and concrete bases are for 15-inch Rodman guns. (GN.)

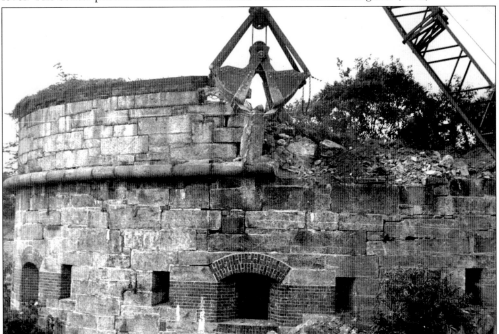

Some historic fortifications have been destroyed when newer emplacements and buildings had to be built where the old ones stood. Most of the granite fort at Sandy Hook and the front of old Fort Hamilton were removed for this reason. However, the army demolished Hamilton's redoubt in 1952, pulling out its well-fitted stones with a clamshell crane, and the navy buried most of the Endicott batteries at Wadsworth in the 1980s—both because they seemed to spoil the view. (HM.)

ACKNOWLEDGMENTS

Many people were especially helpful in the preparation of this book. Felice Ciccione, Mary Rasa, Tom Hoffmann, Barry Moreno, and Jeff Dosik, all of the National Park Service, stand out for their kindness and knowledge, both of which they always gave to us willingly. Jack Fine, a retired warrant officer from Fort Totten and its longtime historian, shared all his materials and anecdotes and made our visits there most productive. At Fort Hamilton, Barry Moldano and Richard Cox of the Army Museum System opened their well-organized museum and archives to us, as did Eric Johannsson of the New York State Maritime College at Fort Schuyler. Karl Schmidt shared his postcard collection for this book, as did Roger Davis, and we truly appreciate the otherwise unavailable photographs they found. Ideas and assistance also flowed from Elliot Deutsch, who arranged our fascinating visits to Aberdeen Proving Ground, and from B.W. Smith, Alex Holder, and Steve Wiezbicki, who found photographs neither of us knew existed.

Four books were of inestimable help and are highly recommended: *American Seacoast Defenses: A Reference Guide*, by Mark Berhow, published by the Coast Defense Study Group; *Rings of Supersonic Steel*, by Mark Morgan and Mark Berhow, published by the Fort MacArthur Museum Association; *A Legacy of Brick and Stone*, by John Weaver, published by Redoubt Press; and Robert Roberts's *Encyclopedia of Historic Forts*, published by Macmillan.

Photographs are keyed as to source by these notations: (BS) Bolling Smith collection; (EI) Ellis Island, National Park Service; (GN) Gateway National Recreation Area, Fort Wadsworth, National Park Service; (GW) Glen Williford collection; (HM) Army Museum Service, Fort Hamilton; (KS) Karl Schmidt collection; (NA) National Archives and Record Service; (OM) Army Museum Service, Ordnance Museum, Aberdeen Proving Ground; (RD) Roger Davis collection; (SH) Gateway National Recreation Area, Fort Hancock, National Park Service; and (TM) Fort Totten museum collection.

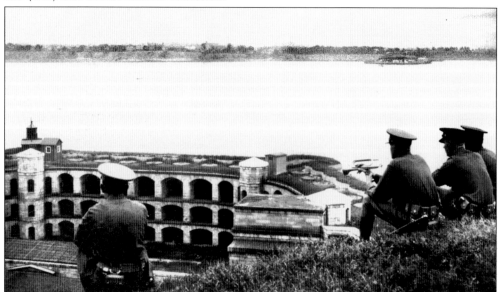

Taps is the final bugle call of the day at army posts. A bugler and his ceremonial guard sit above old Battery Weed at the close of this day, seemingly waiting for the moment when they will signal its end. The end of 400 years of New York City's harbor defenses has certainly come, but the millions of soldiers once stationed there have now been replaced by millions of visitors who may well remember that these forts were once crucially important to America. (GN.)